ZEN LIGHT MANDALAS

Adult Coloring Book for Meditation, Mindfulness, Relaxation, and Stress Relief

This Book Belongs To:

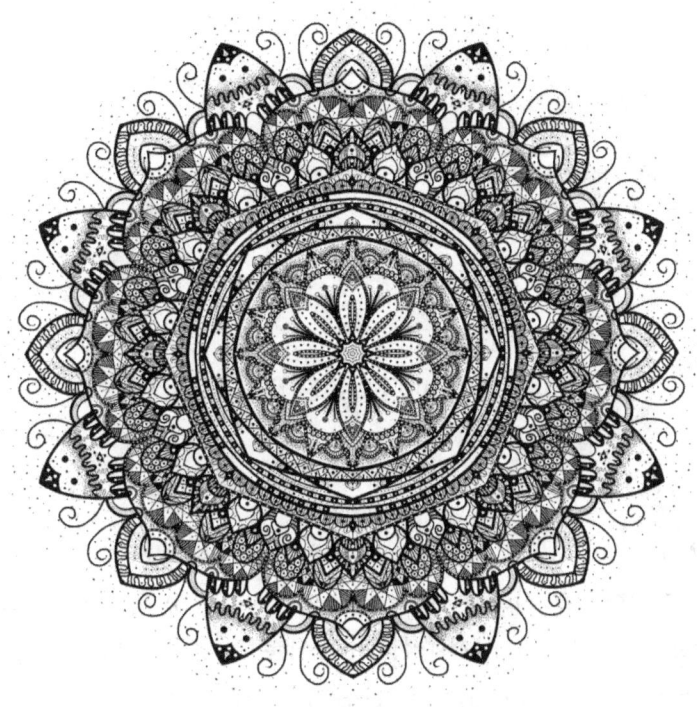

ZEN LIGHT MANDALAS
Adult Coloring Book for Meditation,
Mindfulness, Relaxation, and Stress Relief

Copyright December 2019
Melody Michaels
Coloring Book Shoppe

All rights reserved. No part of this book may be reproduced for any commercial endeavor without the written consent of the author.

DISCOVER THE ZEN ARTIST IN YOU!

Beautiful, Intricate, Unique, STUNNING MANDALAS

Coloring Therapy improves:

- RELAXATION
- MEDITATION
- MINDFULNESS
- STRESS-RELIEF
- CREATIVITY
- SELF-CONFIDENCE
- CONNECTIVITY TO YOUR INNER CHILD
- FREEDOM TO COLOR INSIDE OR OUTSIDE THE LINES

Become the CALM CONFIDENT CREATIVE person you can be.

Much research has been conducted on the health benefits of coloring for both adults and children. Many doctors are now convinced that engaging in fine motor movements of the hands has numerous stress reduction benefits. The reason behind the enhanced therapeutic effects of mandala coloring is the use of fine repetitive movements that give one the ability to stay focused on the activity which produces mindfulness or "being in the present moment". The result is positive physiological changes and a relaxation effect within the body.

Physical Benefits of Mandala Coloring

- Lowers blood pressure and pulse rate
- Boosts immune system
- Decreases oxygen consumption
- Lowers cortisol production (stress hormone)
- Refreshes the brain
- Therapy for disease

HUMANS LOVE CIRCLES!

The earth is round. The sun is round, and so is the moon. What else is round? Planets, stars, tree rings, and raindrops. Eyeballs, flowers, buttons, and bottle caps. Clocks, marbles, skittles, and dinner plates. Clouds in the sky form in variations of circles. The wind blows in circular motions. Experience brings us full-circle. Life is a revolution, a circle. No wonder mandala coloring helps us.

WHY COLOR MANDALAS?

According to authors of the study "Can Coloring Mandalas Reduce Anxiety", coloring the symmetrical designs in mandalas helps to draw the mind into a state similar to that achieved by meditation which calms inner chaos and organizes frenzied thoughts. The authors of this study tested their theory on 84 undergrad students suffering from anxiety. At the end of the study, the conclusion was that coloring a mandala for 20 minutes was more effective than free form coloring for 20 minutes. The authors were also able to demonstrate that students who colored on a blank piece of paper showed no reduction in anxiety while those who colored mandalas actually decreased their anxiety levels. According to the Sanskrit language, the word 'mandala' means 'circle' or 'center'. These circles are spiritual symbols representing the universe in Buddhism and Hinduism. Mandalas have concentric circles that grow outwardly and these represent harmony and fullness in the mind and in the universe. Mandala coloring improves relaxation, calms the nervous system, invokes positive energies, and balances body energies.

Benefits of Mandala Coloring Include:

1. Stress Relief

Most everyone in modern society is multi-tasking to the extreme. We juggle job and family and financial concerns. We struggle to co-exist with family members, co-workers, and community members. No matter how busy we are, mental health should not be ignored. Since this activity requires attentiveness, the result is enhanced concentration which brings calmness. This deep engagement in coloring reduces anxiety and brings stress-relief.

2. Therapeutic Effect

As studies have shown, mandala coloring provides significant healing power. Coloring can reduce negative and unpleasant thoughts. The special properties of mandalas are effective in organizing thoughts and feelings. The circular patterns of mandalas have a magical healing power which can have a recuperative effect.

3. Meditation Alternative

Many people work to balance their mind and body through meditation. Studies of psychology show that mandala coloring has the same effect as that of meditation. The shapes and patterns of mandala designs require deep engagement. Coloring mandalas helps to order thought processes, disengage from feelings of anxiety, and acquire positive thoughts.

4. Refreshes the Brain

Mandala coloring not only reduces anxiety, but also refreshes your brain. When you color, you access both hemispheres of the brain. Coloring activates both the analytical and creative sections of the brain, enhances problem-solving skills, and refines motor skills.

5. Sparks Creativity

Coloring complex circular designs requires creativity. This activity can help you get your mind out of the daily grind. Researchers believe that adults engaged in coloring can rediscover their creative ideas and improve them. Intricate designs spark the brain to choose colors aesthetically. As you continue in repetitive coloring sessions, you can steadily improve your ability to create masterpieces worthy of framing.

6. Boosts Immune System

Geometric patterns found in mandalas represent the cosmos metaphysically. Many who practice modern medicine believe that mandala coloring has become a healing tool. Coloring mandalas is thought to boost the immune system, sharpen brain function, reduce pain, and promote quality sleep.

7. Reconnects with Your Inner Child

Inner child healing therapy is popular among adults who have been the victims of harshness in childhood. Some areas of our lives are connected with issues and unpleasant memories that we carry with us either consciously or unconsciously. Inner child healing therapy through coloring mandala designs helps to reconnect with your inner child to break negative thought patterns. This therapy helps adults to become better persons by loving and accepting themselves. It also boosts self-confidence to face daily challenges.

8. Therapy for Disease

Mandala coloring books are ideal for patients with diseases. Even individuals suffering from epilepsy, though they have physical limitations, can benefit from the calming effect of coloring. Focused coloring can greatly assist those dealing with chronic pain. Continued coloring practice improves and controls jerky hand movements. Coloring concentric circles in mandalas helps to lower and maintain blood pressure levels.

Whether you are religious or spiritual, or not at all, MANDALA coloring promotes calmness and helps you recover from a stressful day. This is not just a fun activity. It is also outstandingly effective as self-help therapy.

Discover the benefits of ZEN LIGHT
Mandala Coloring Magic

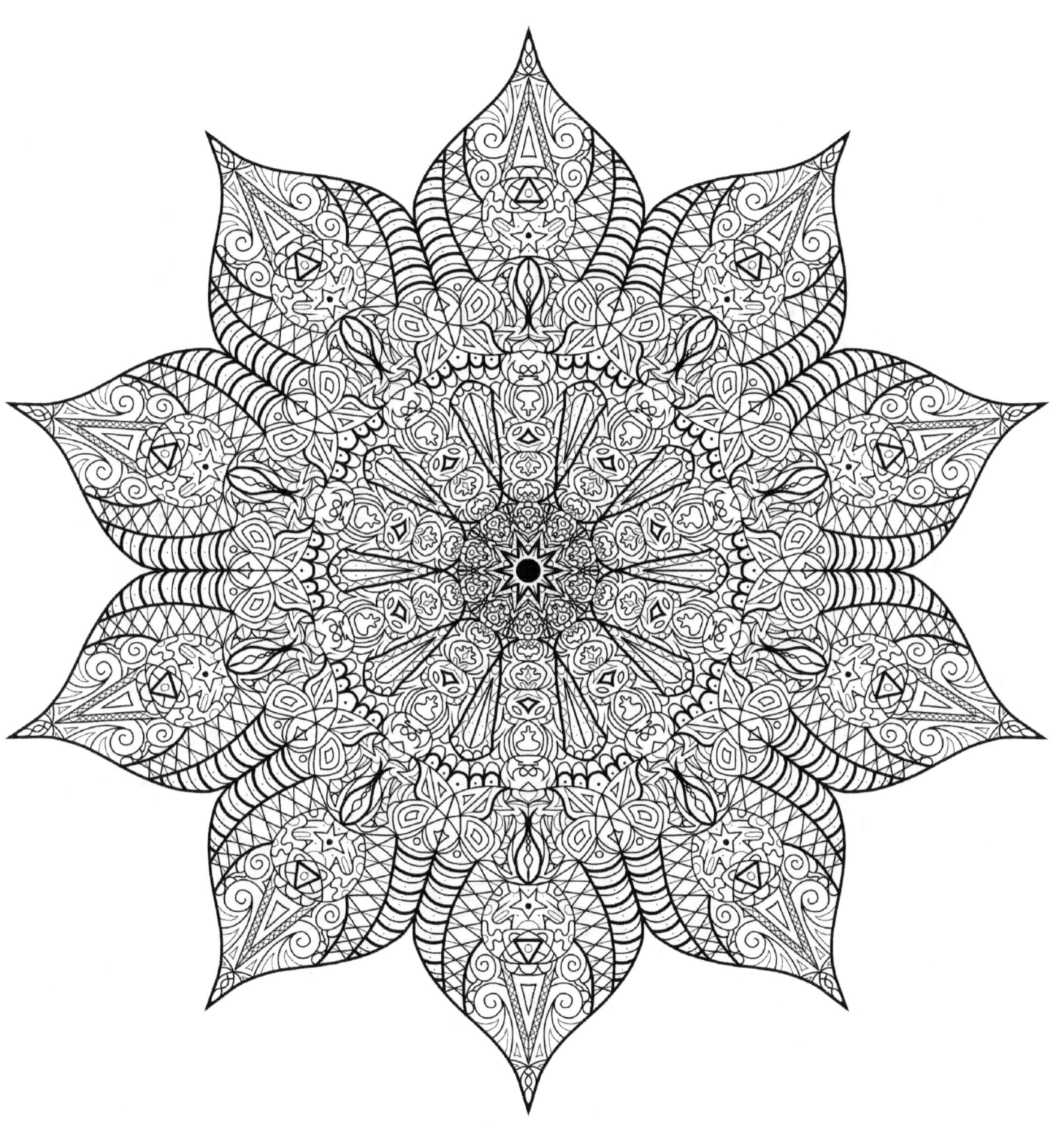

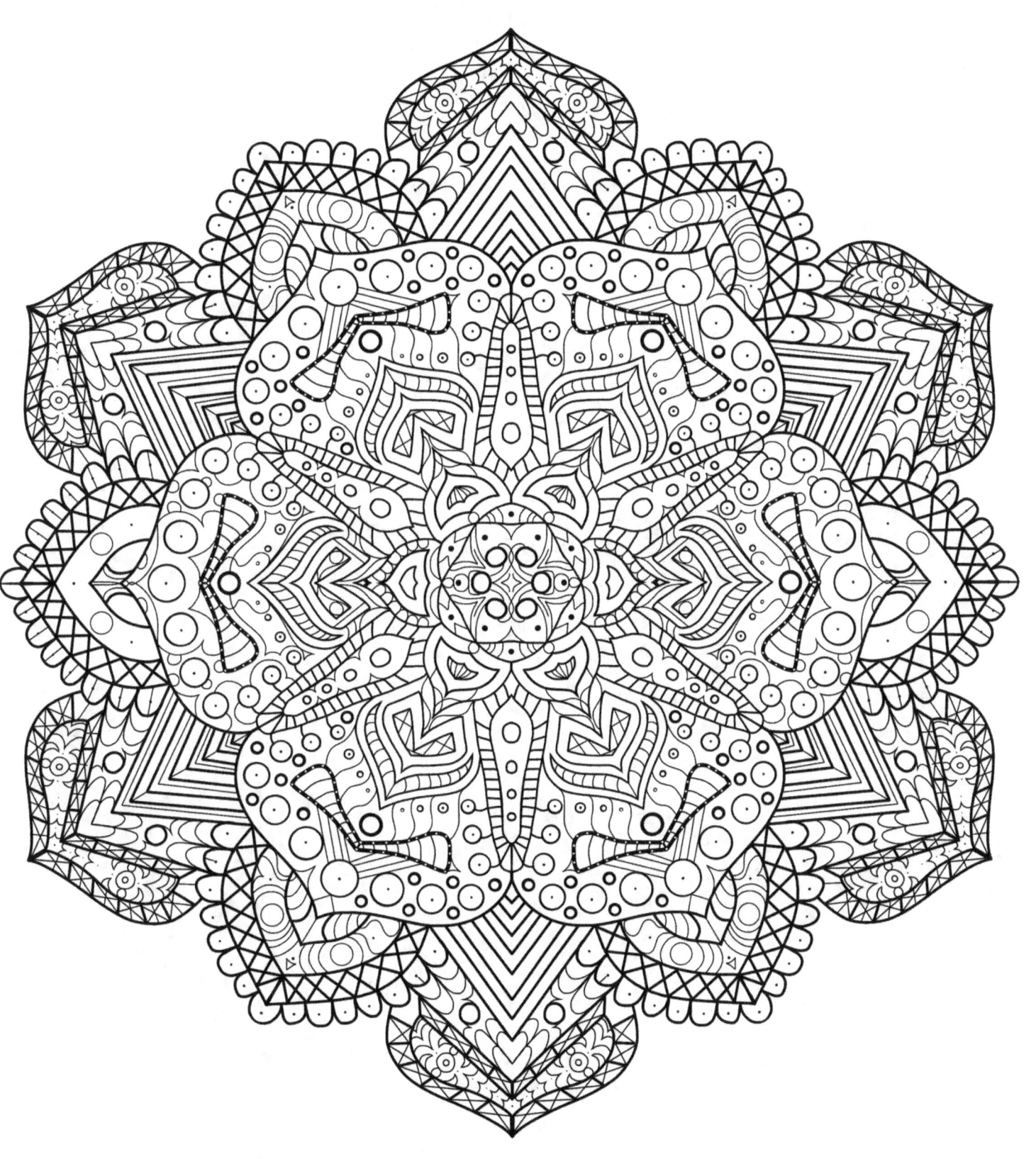

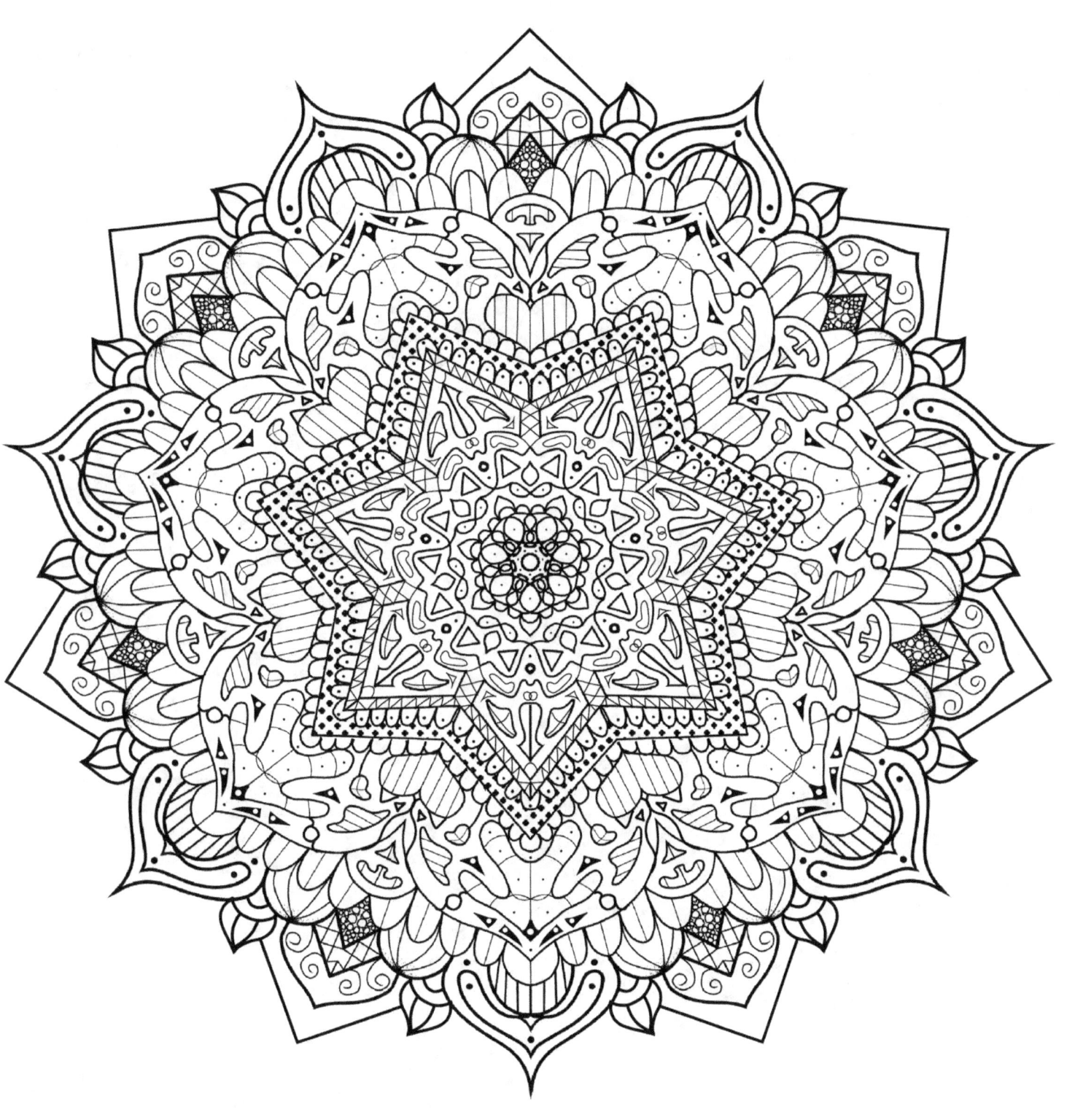

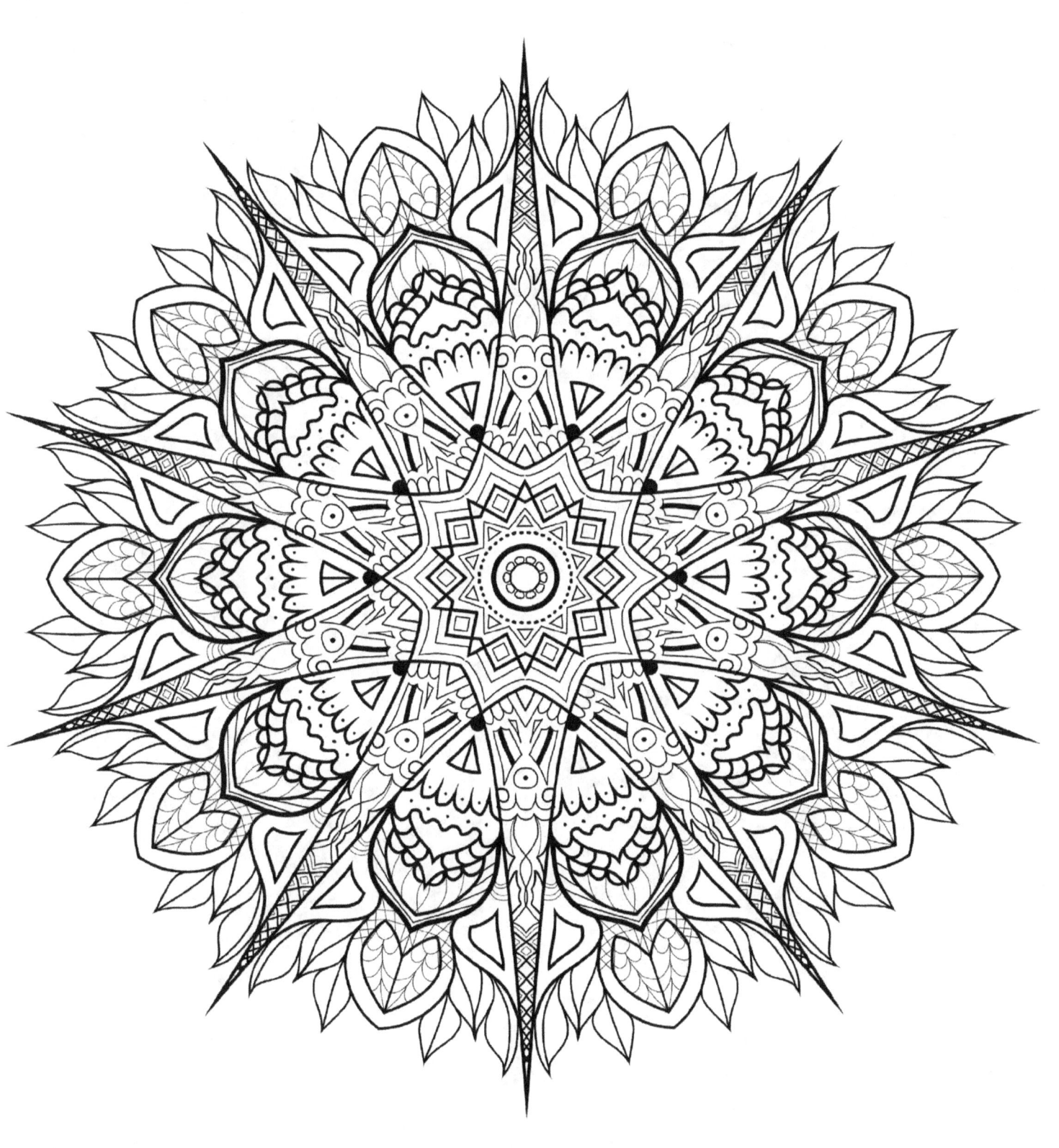

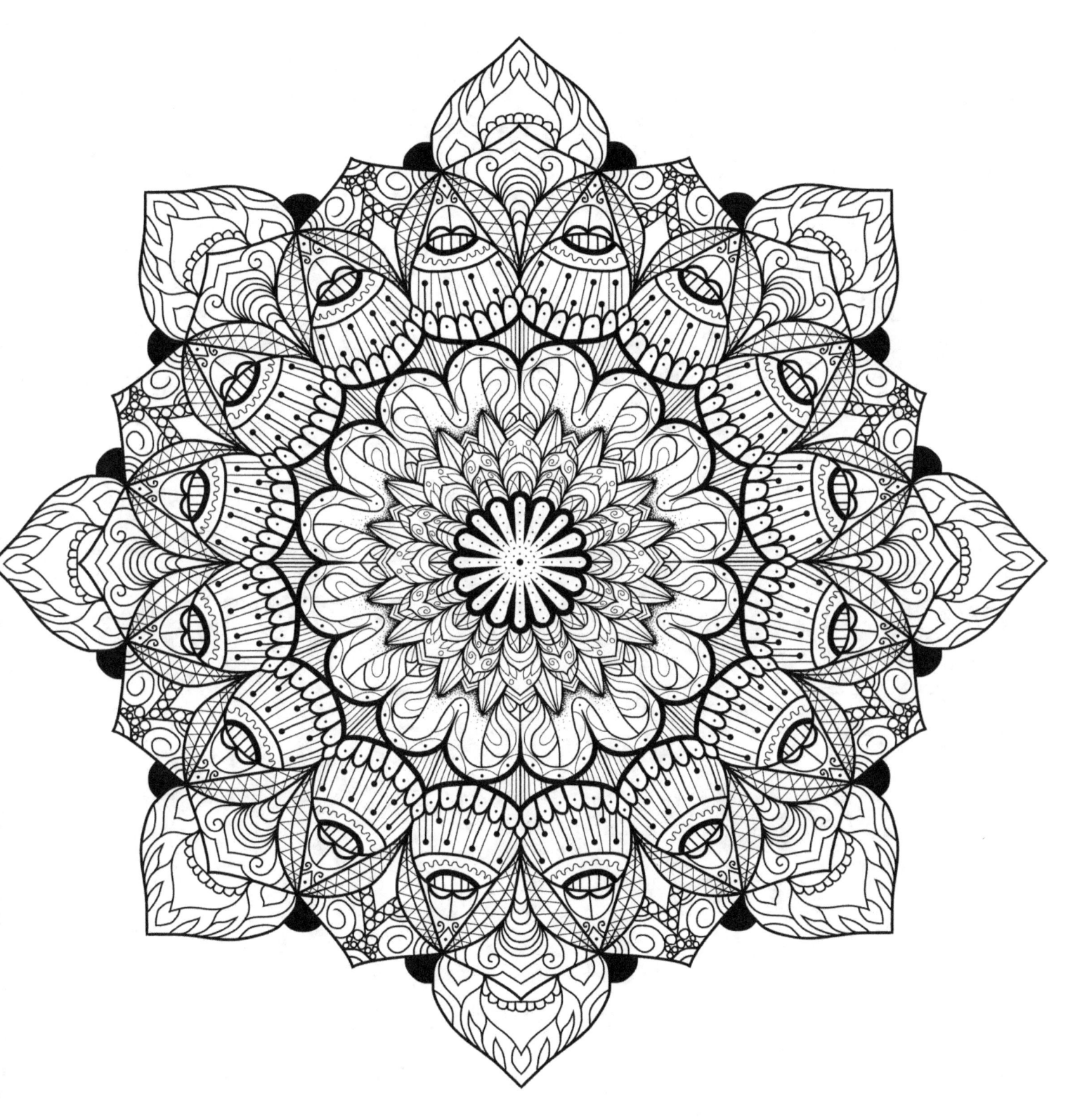

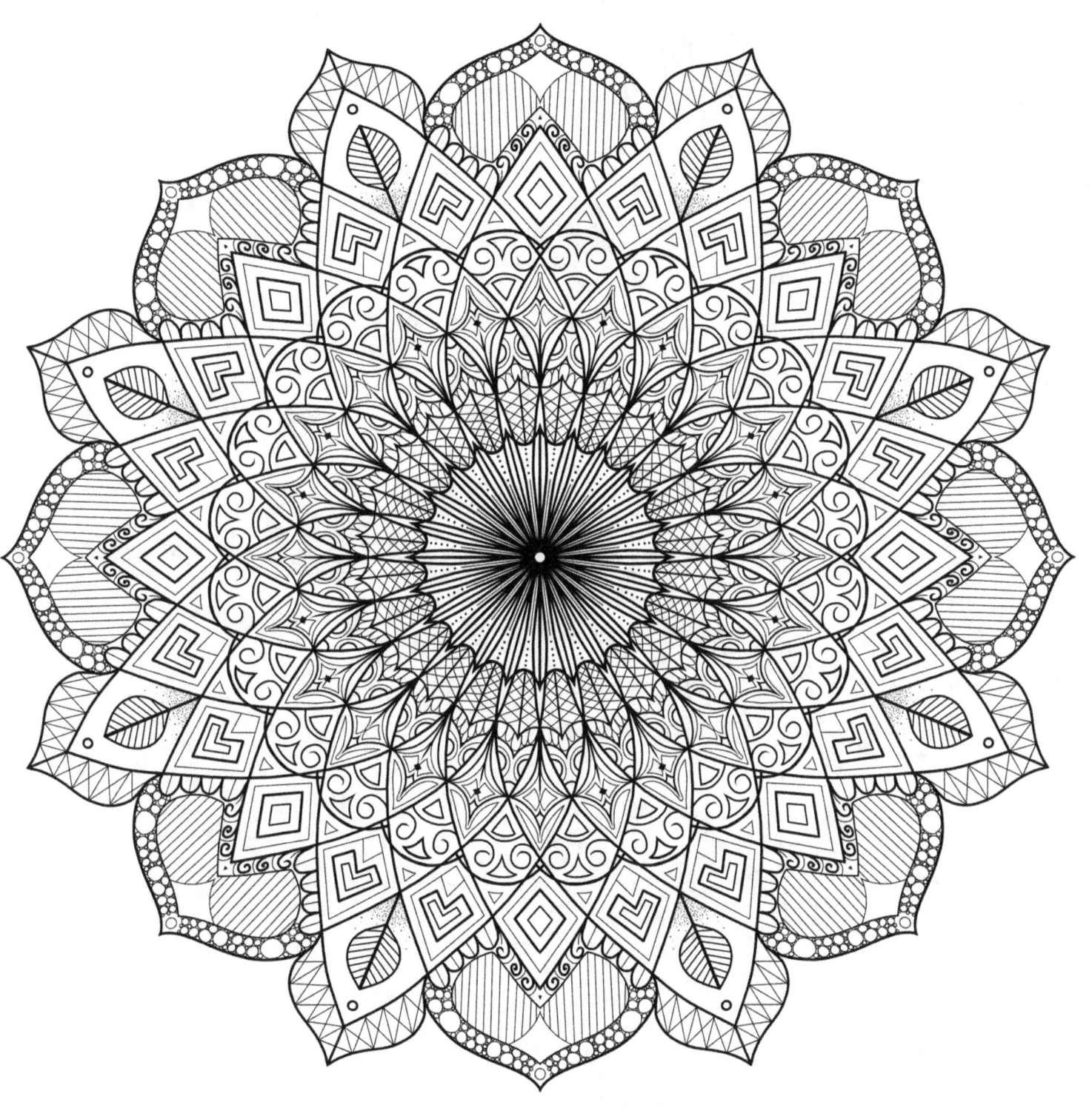

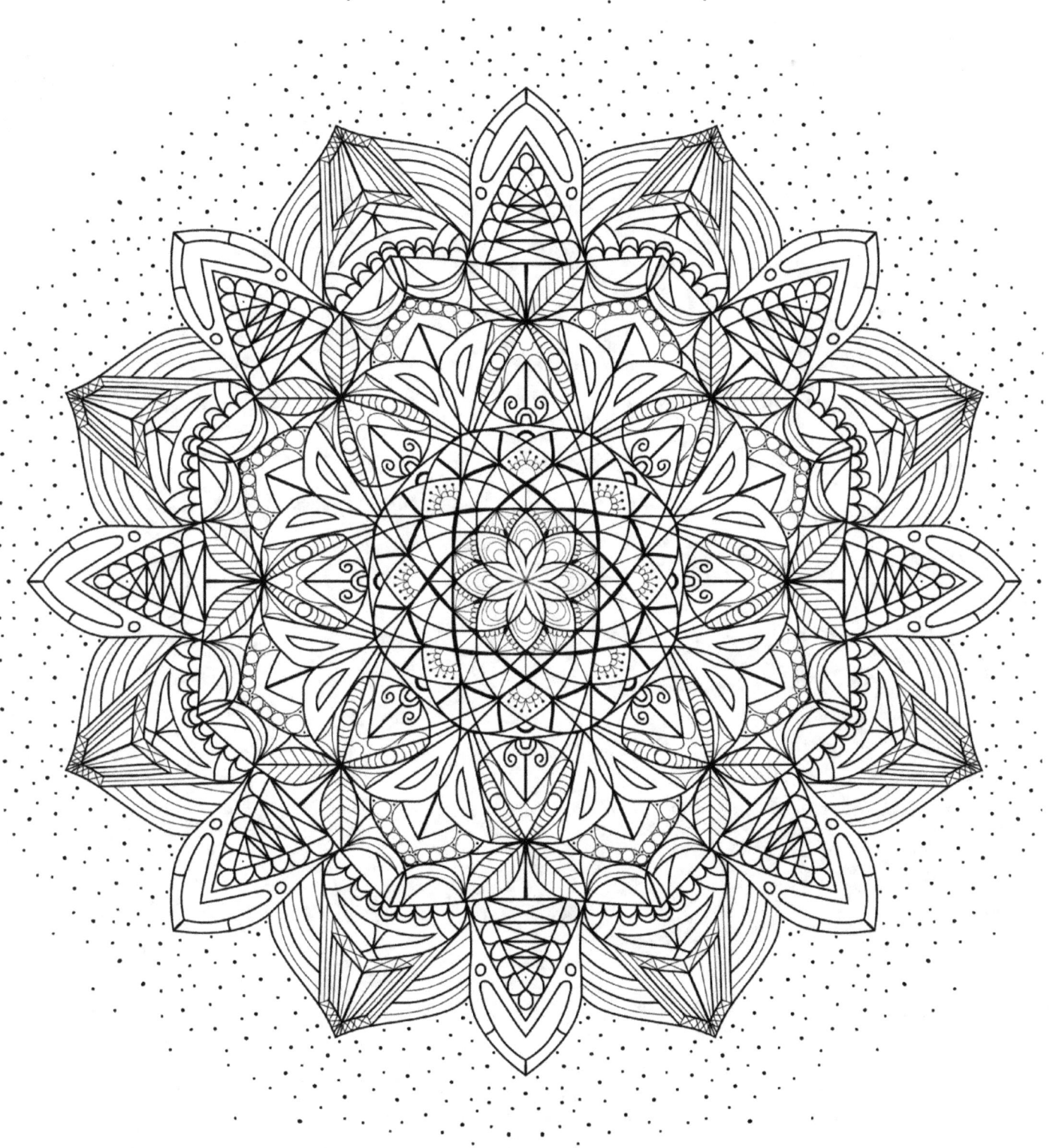

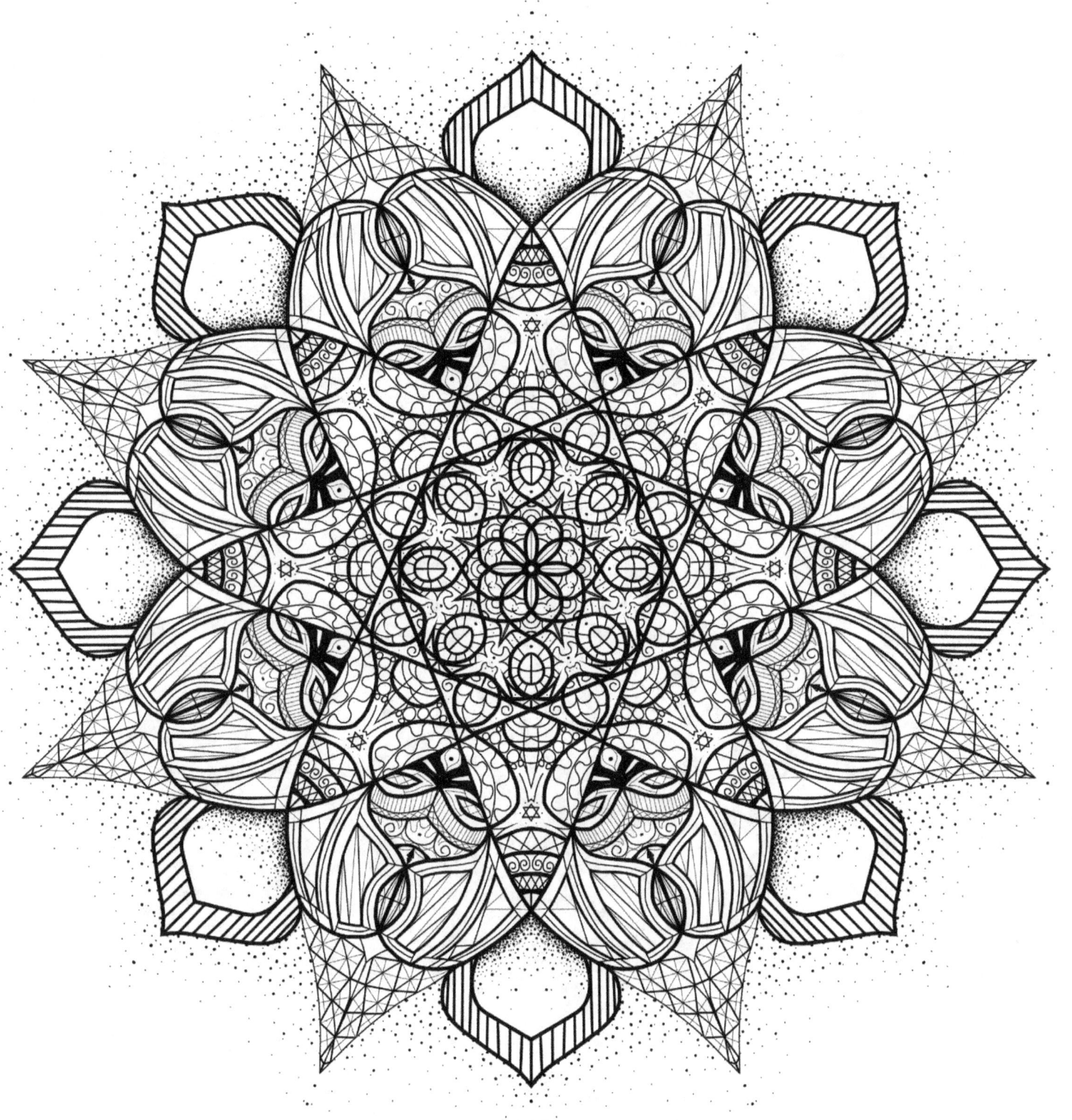

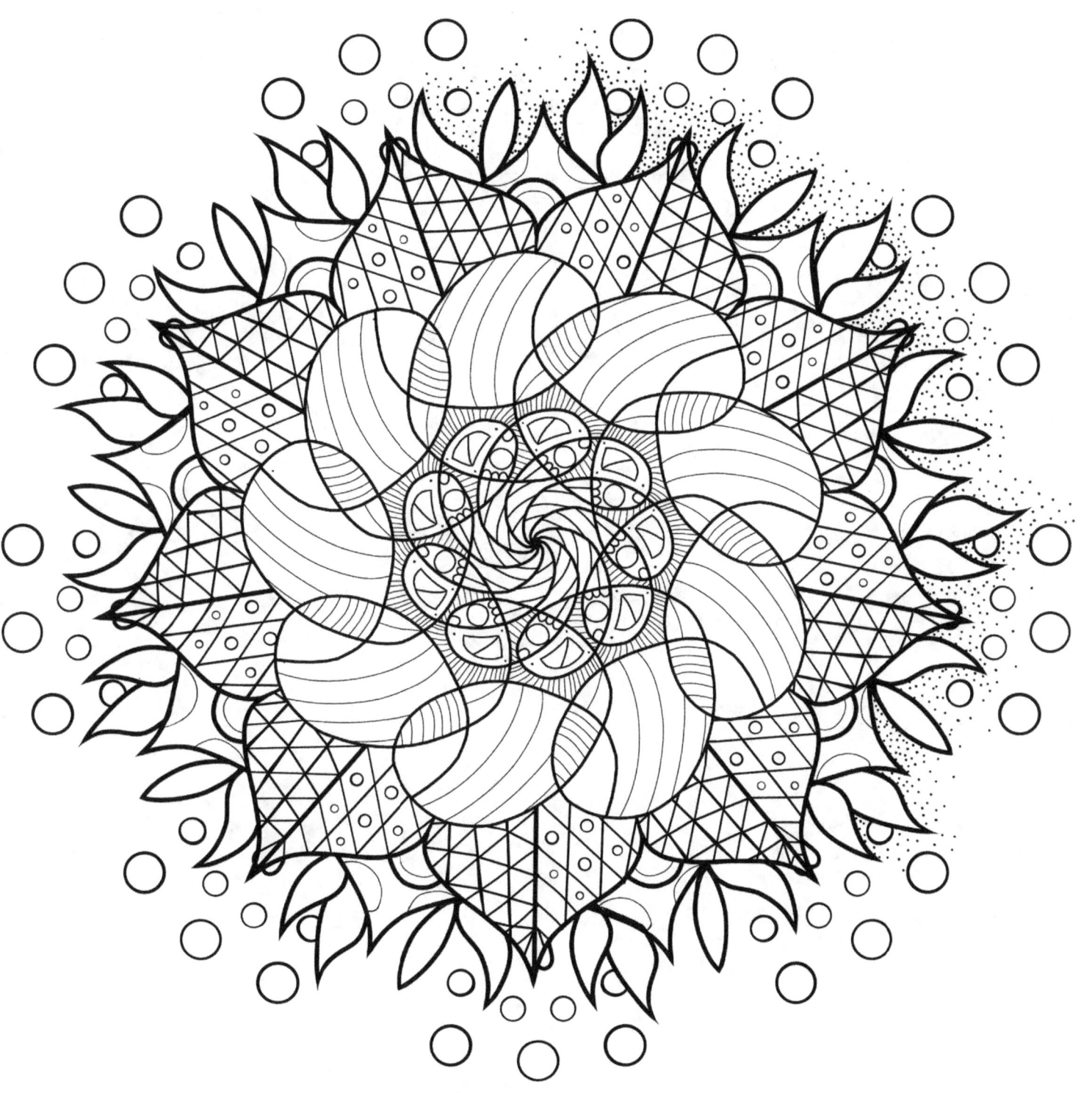

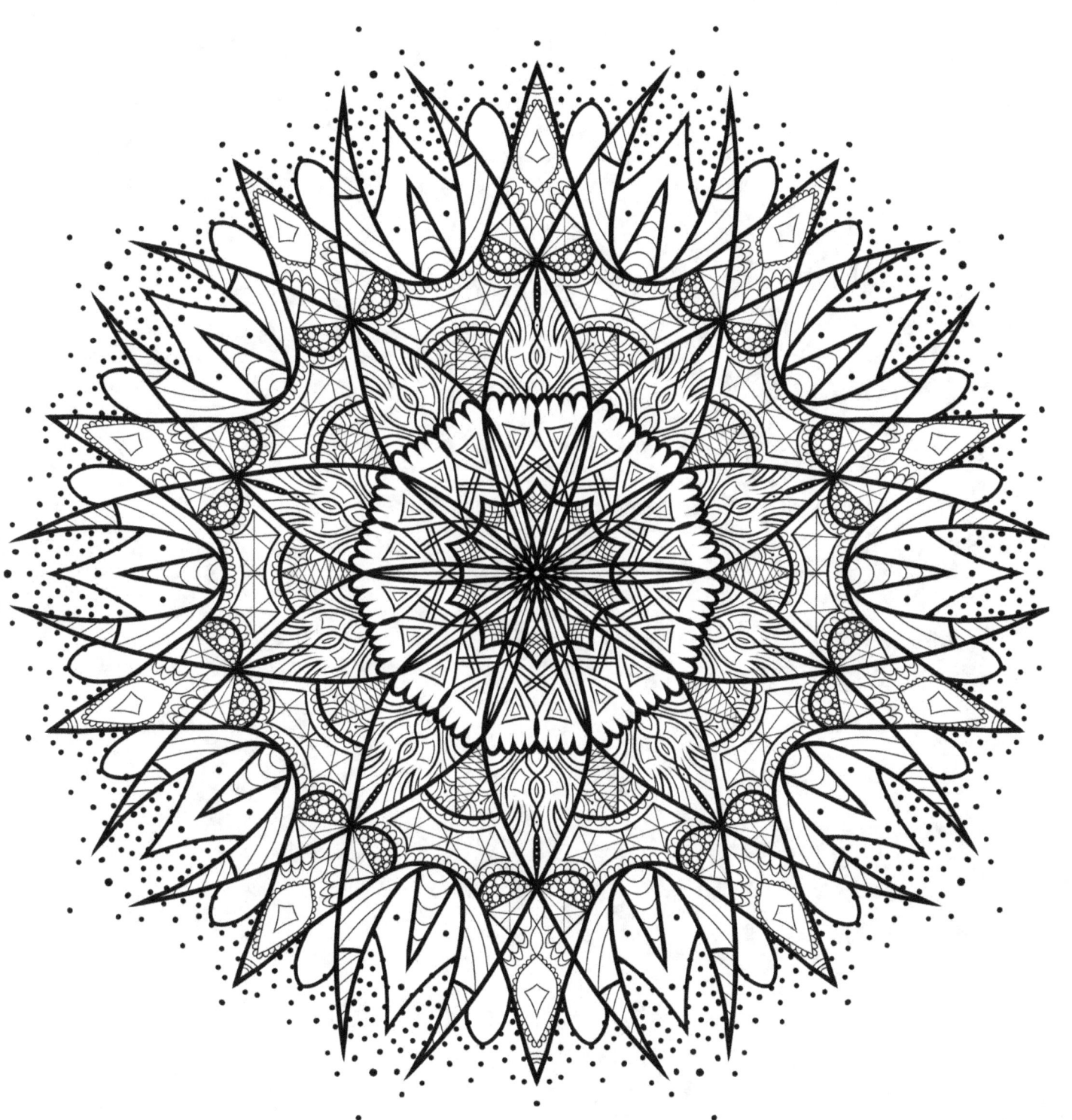

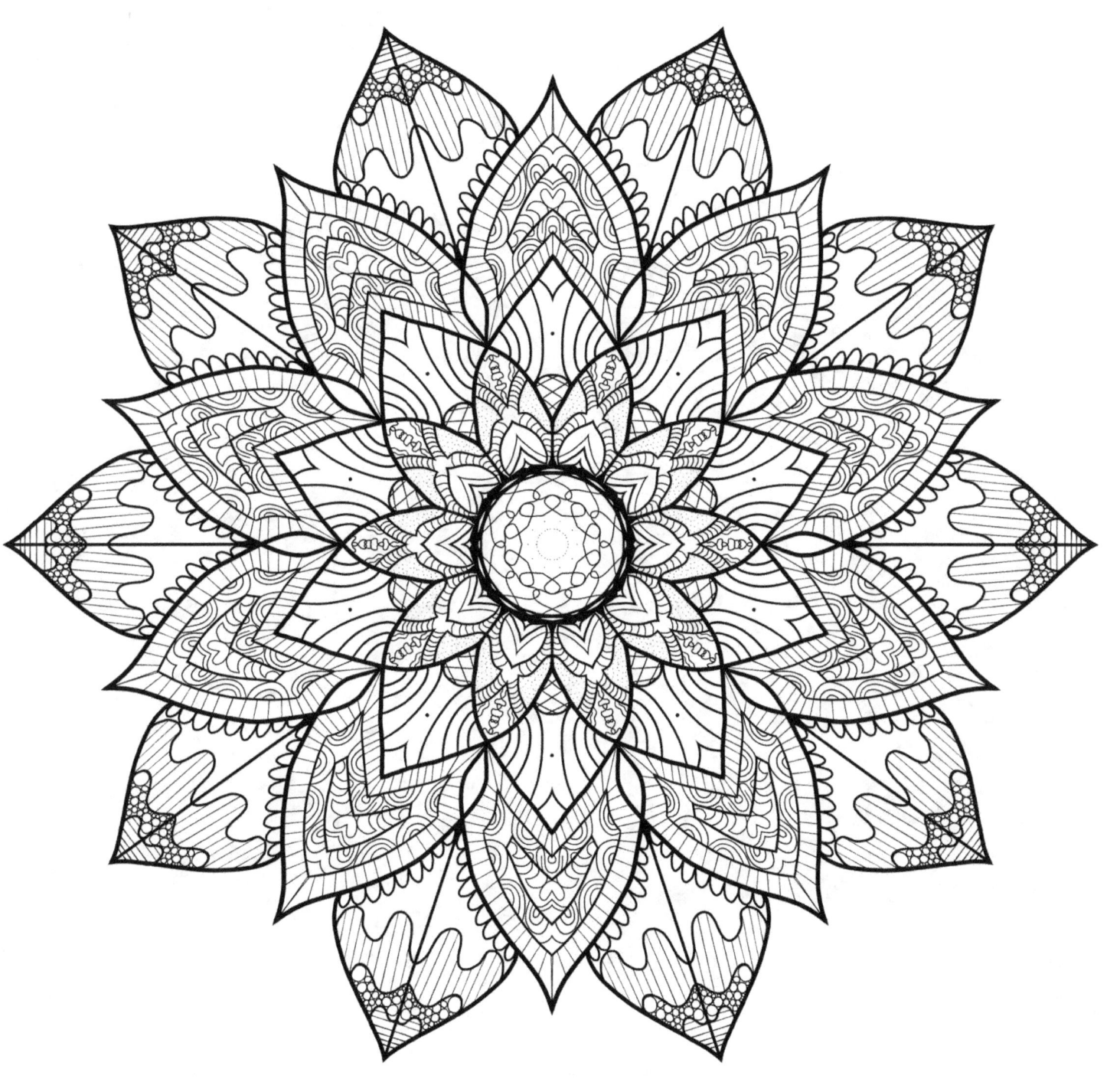

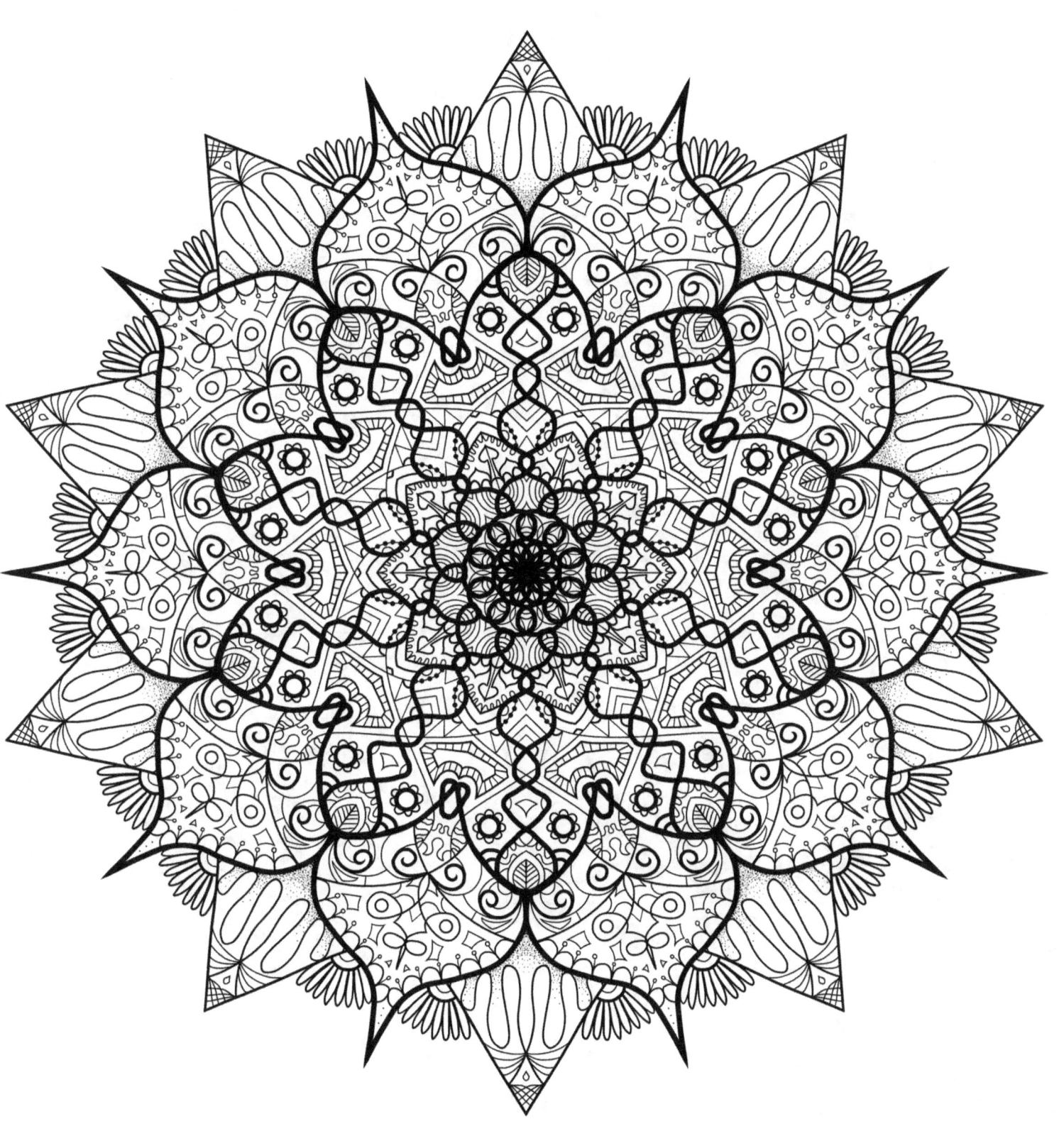

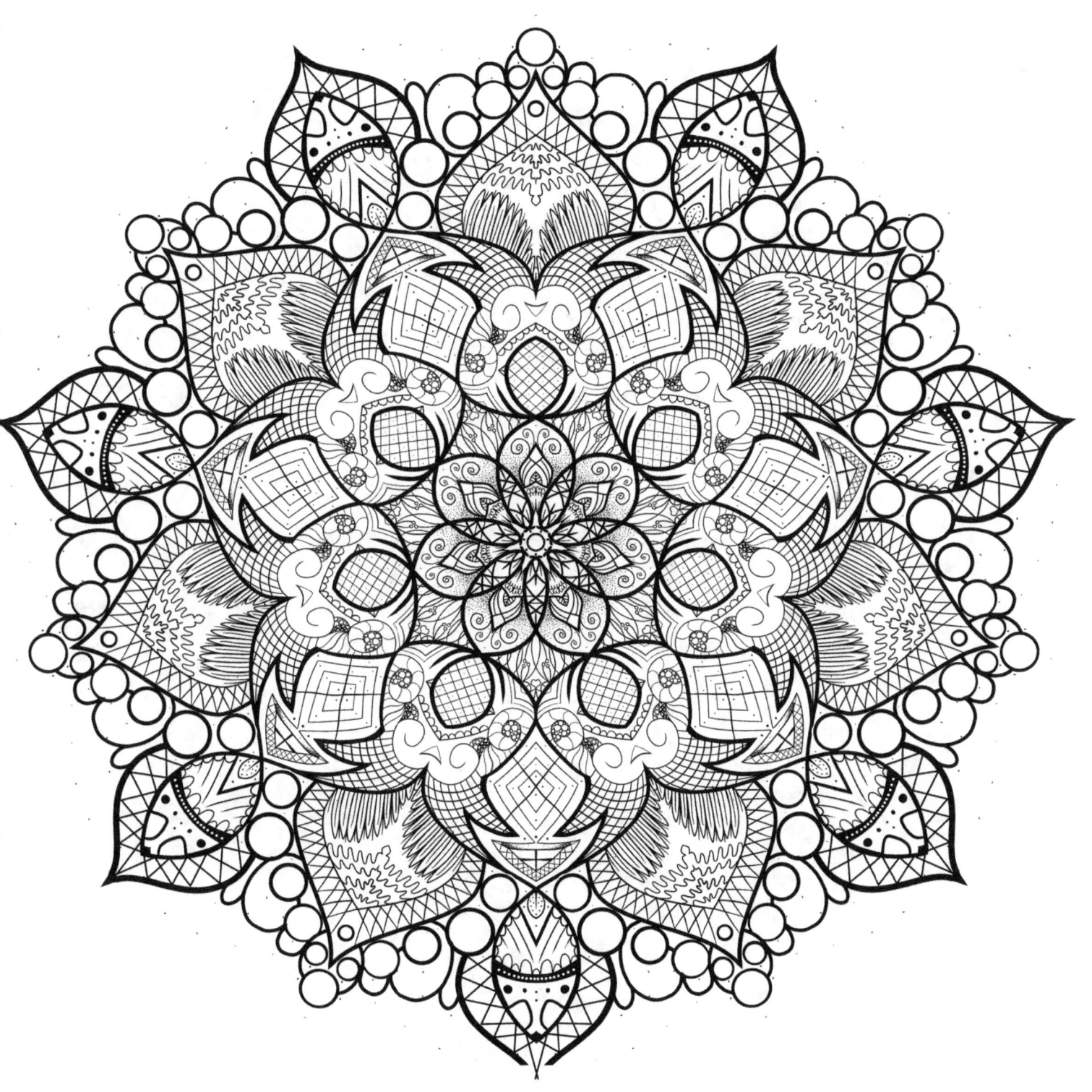

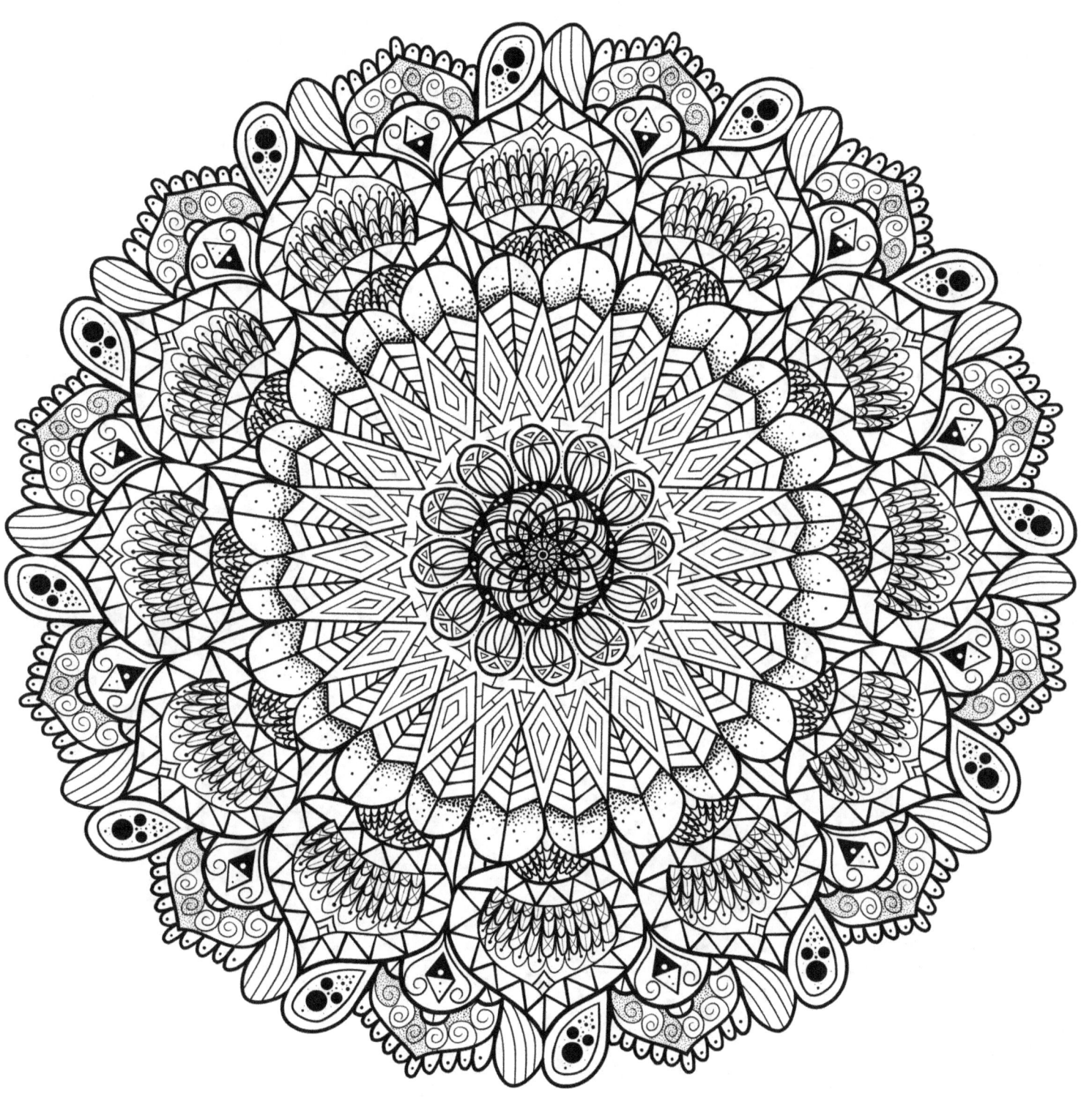

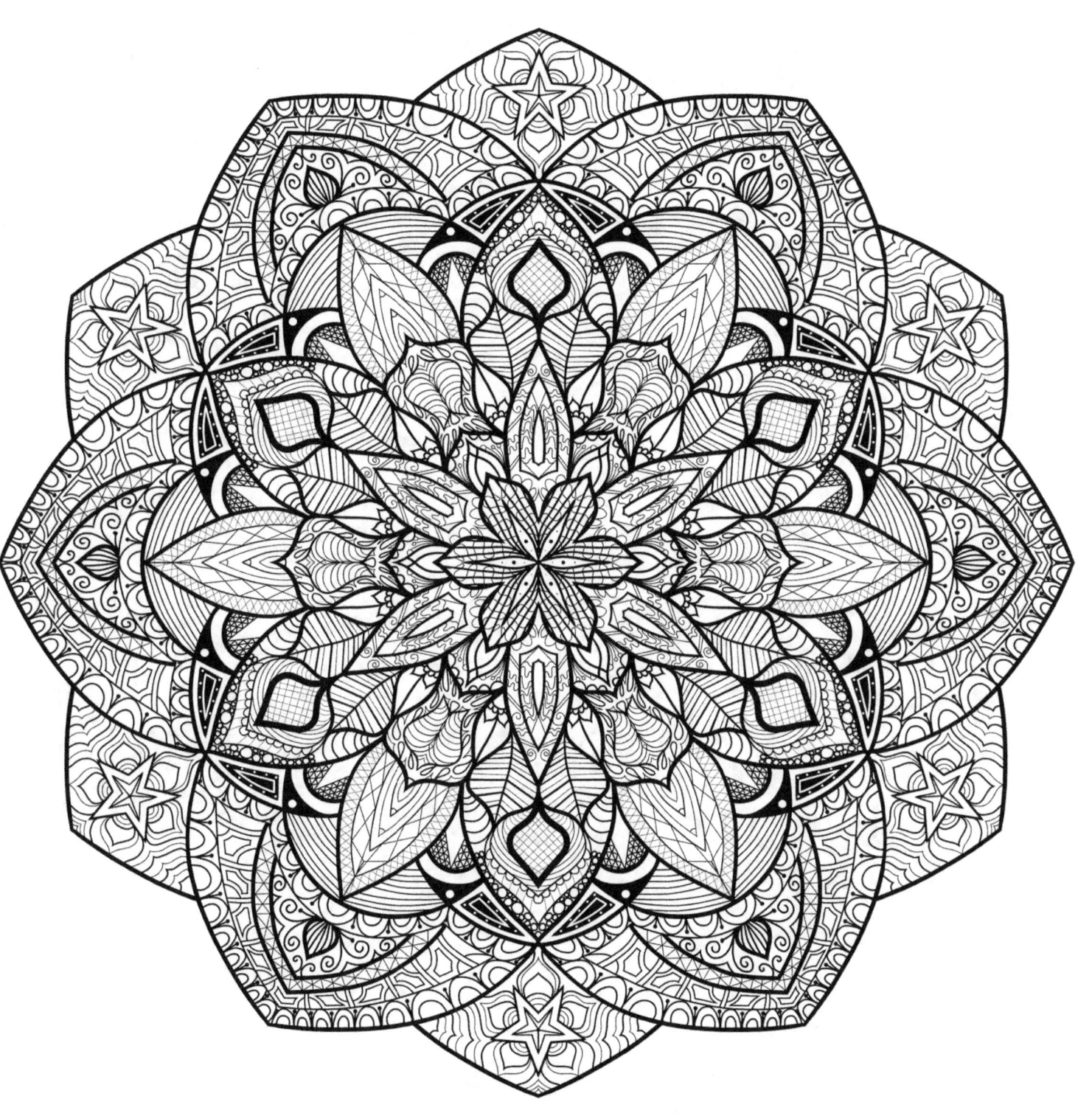

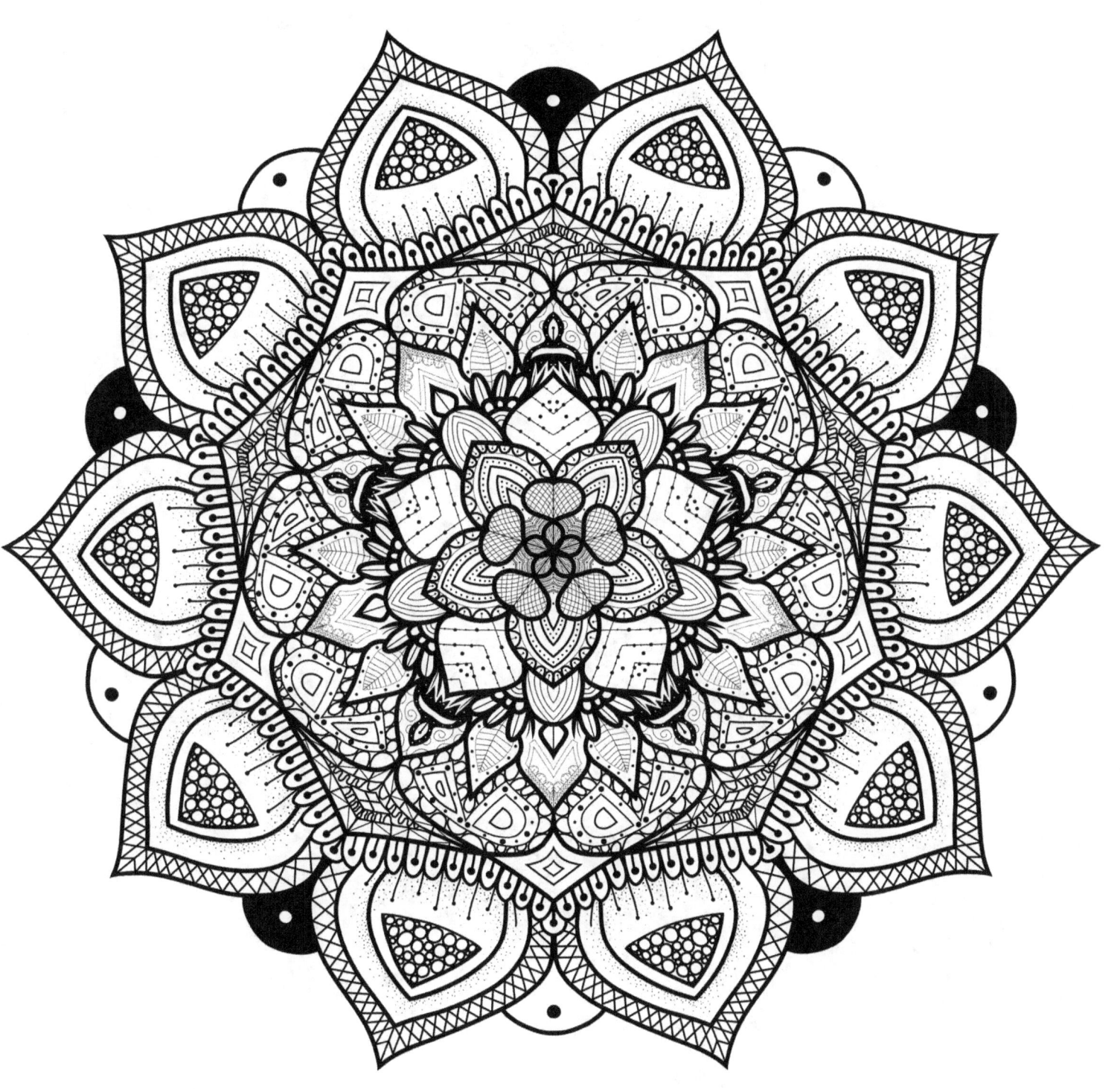

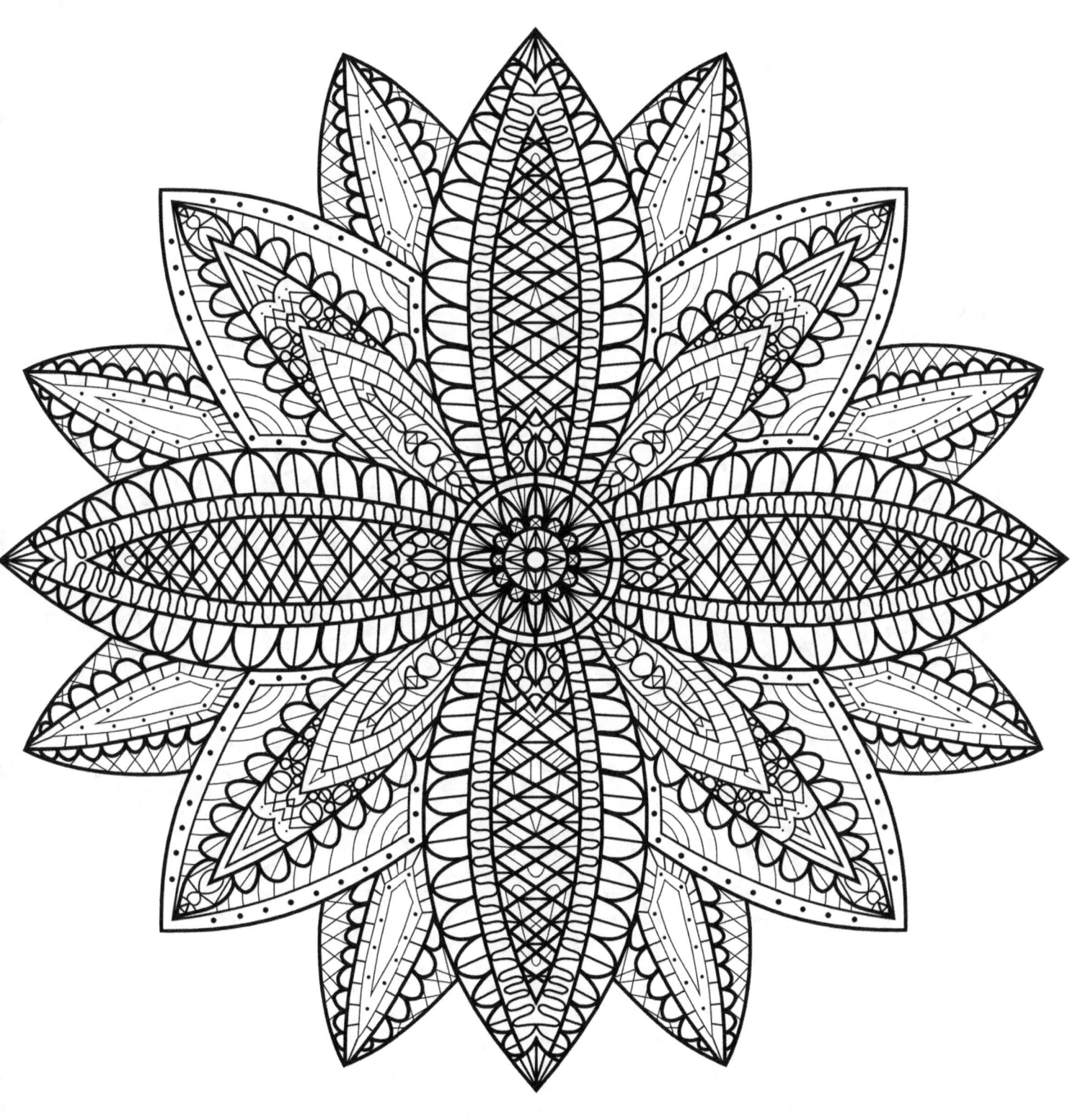

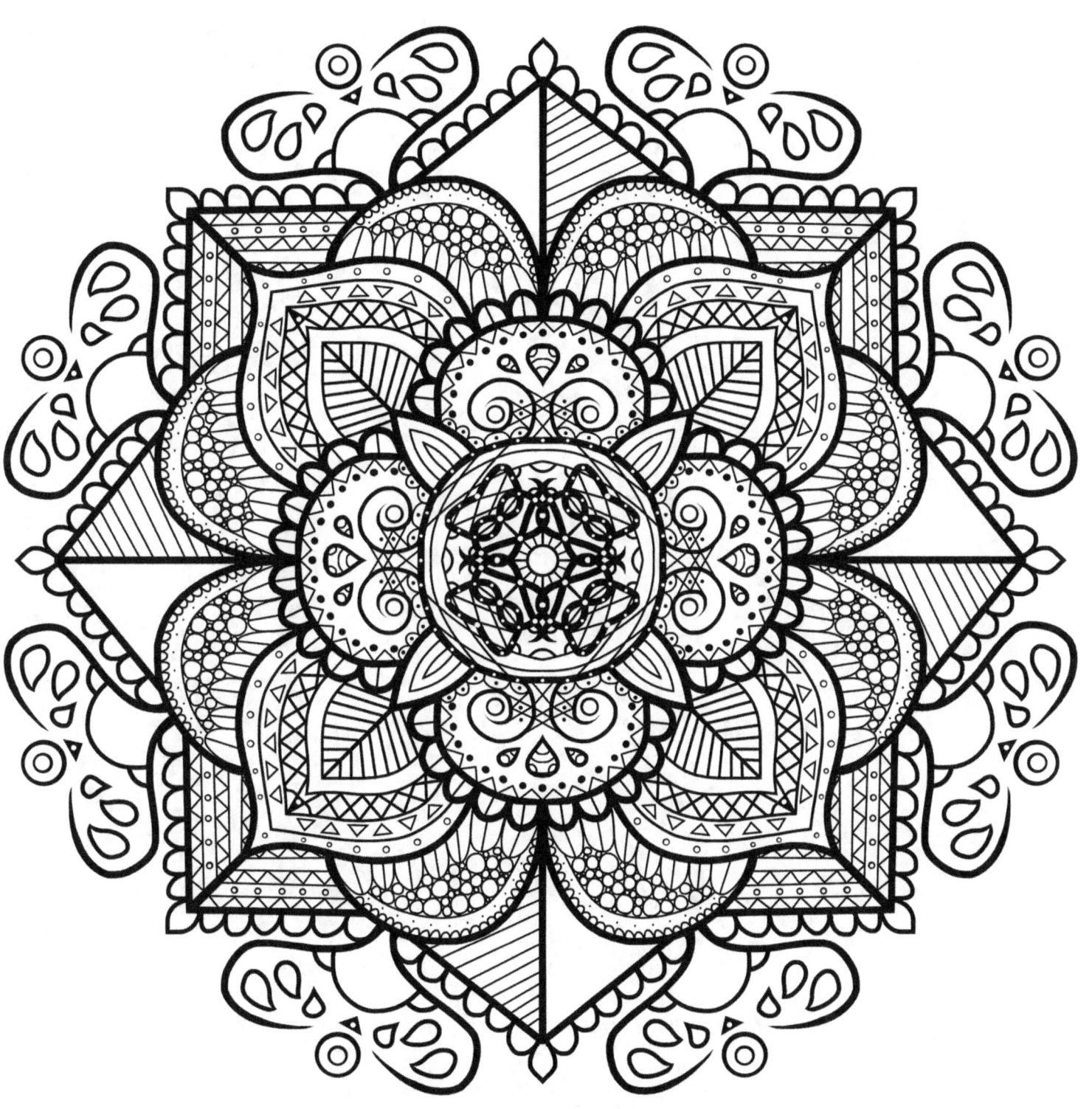

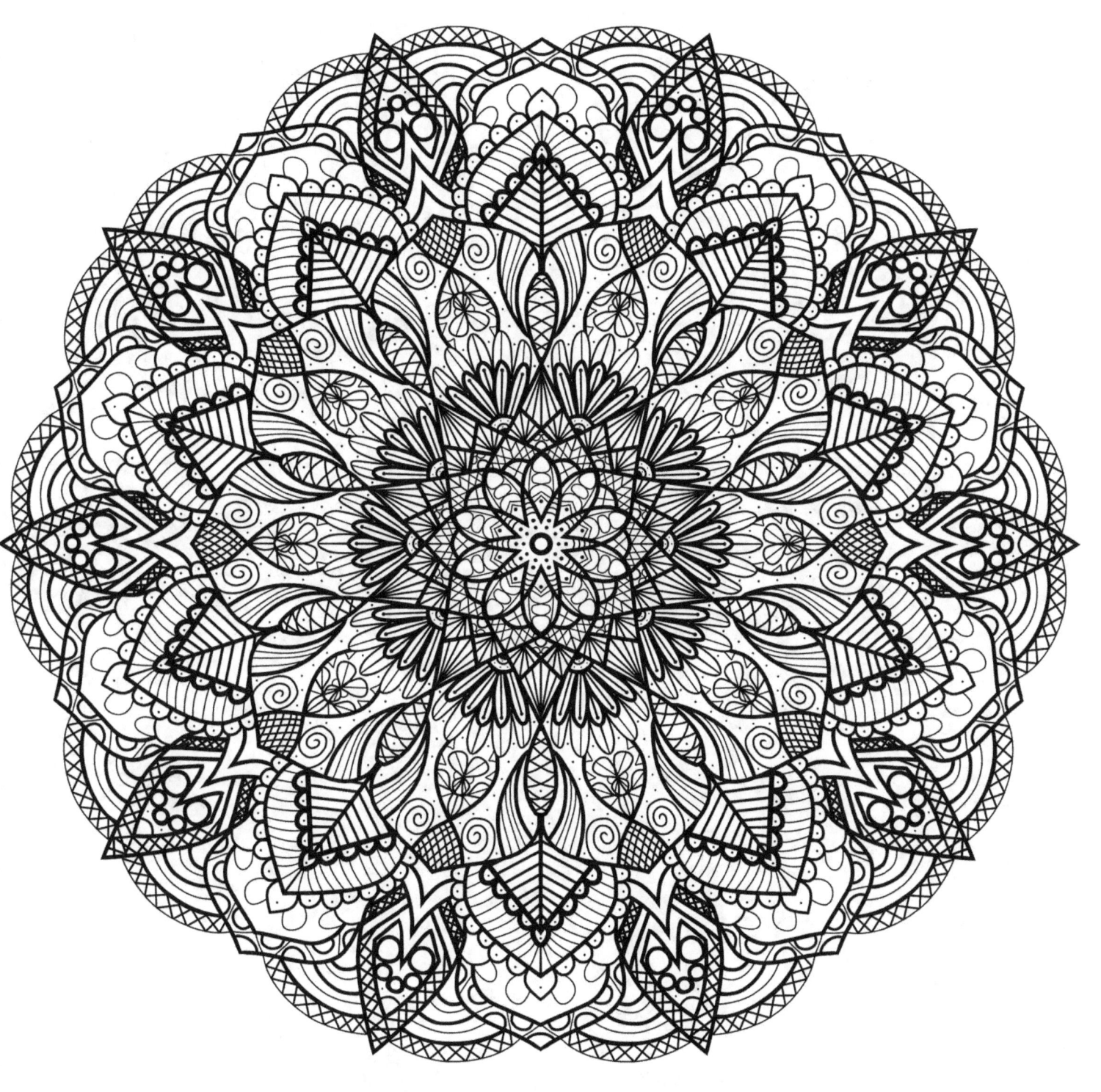

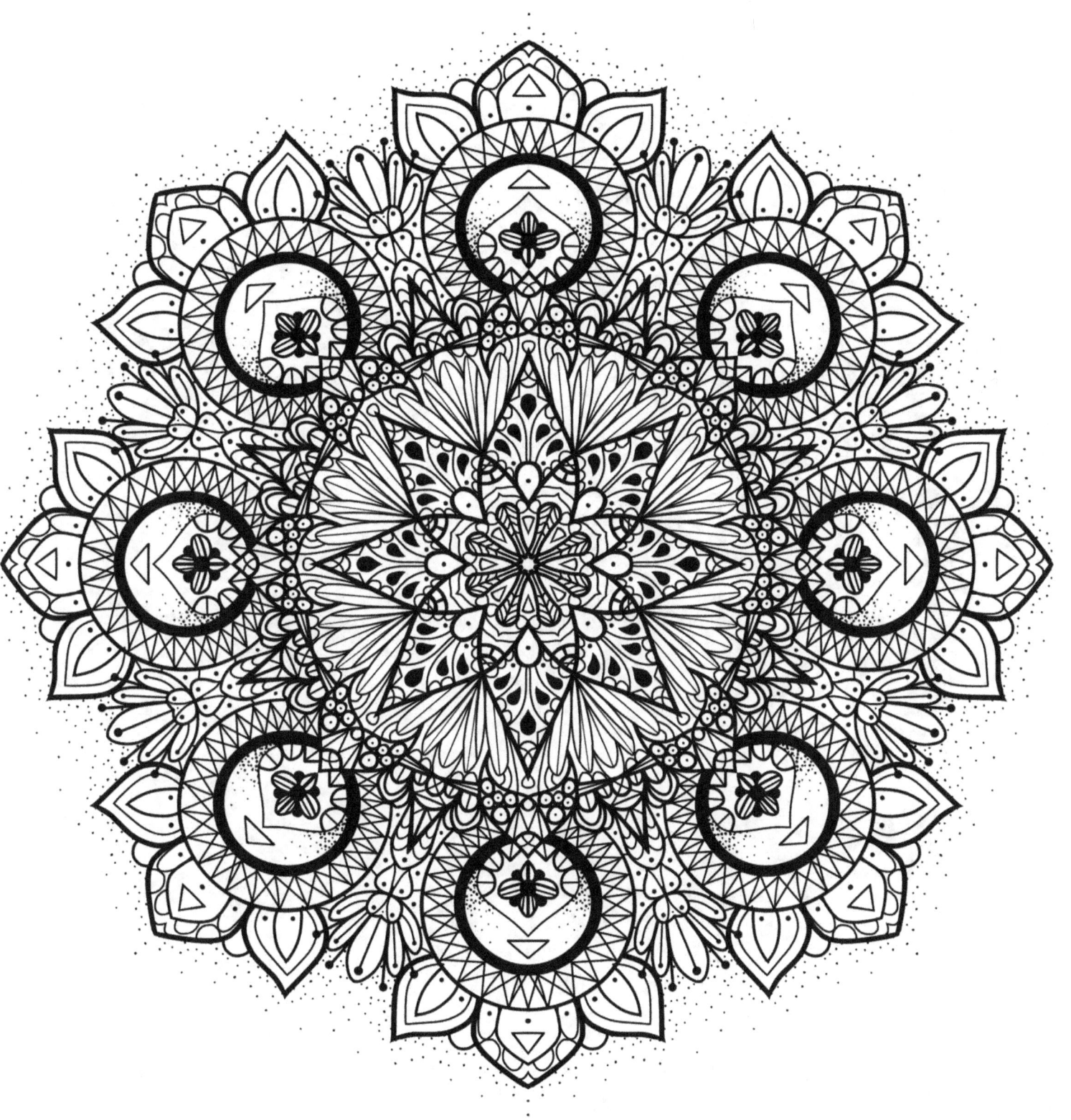

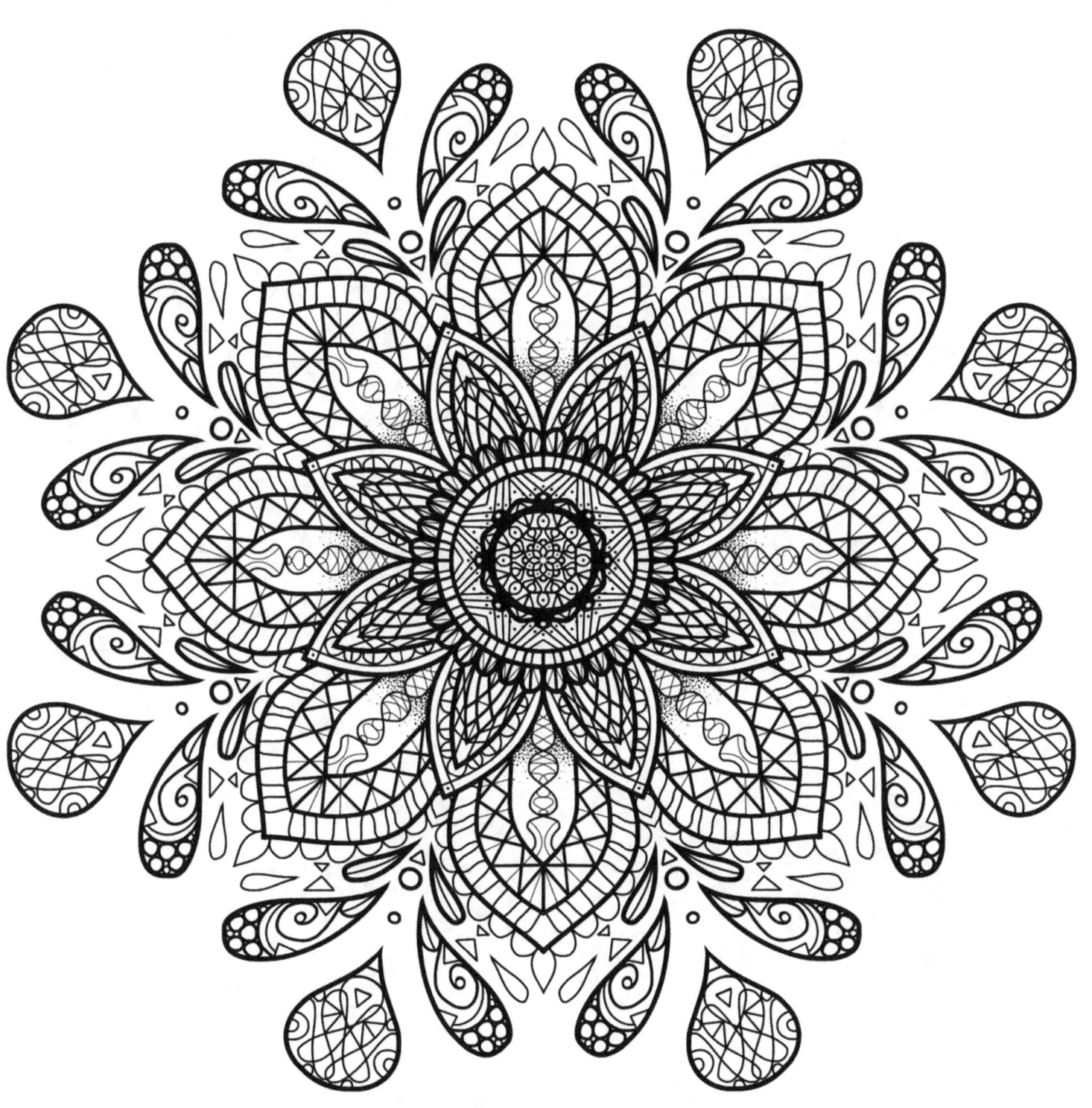

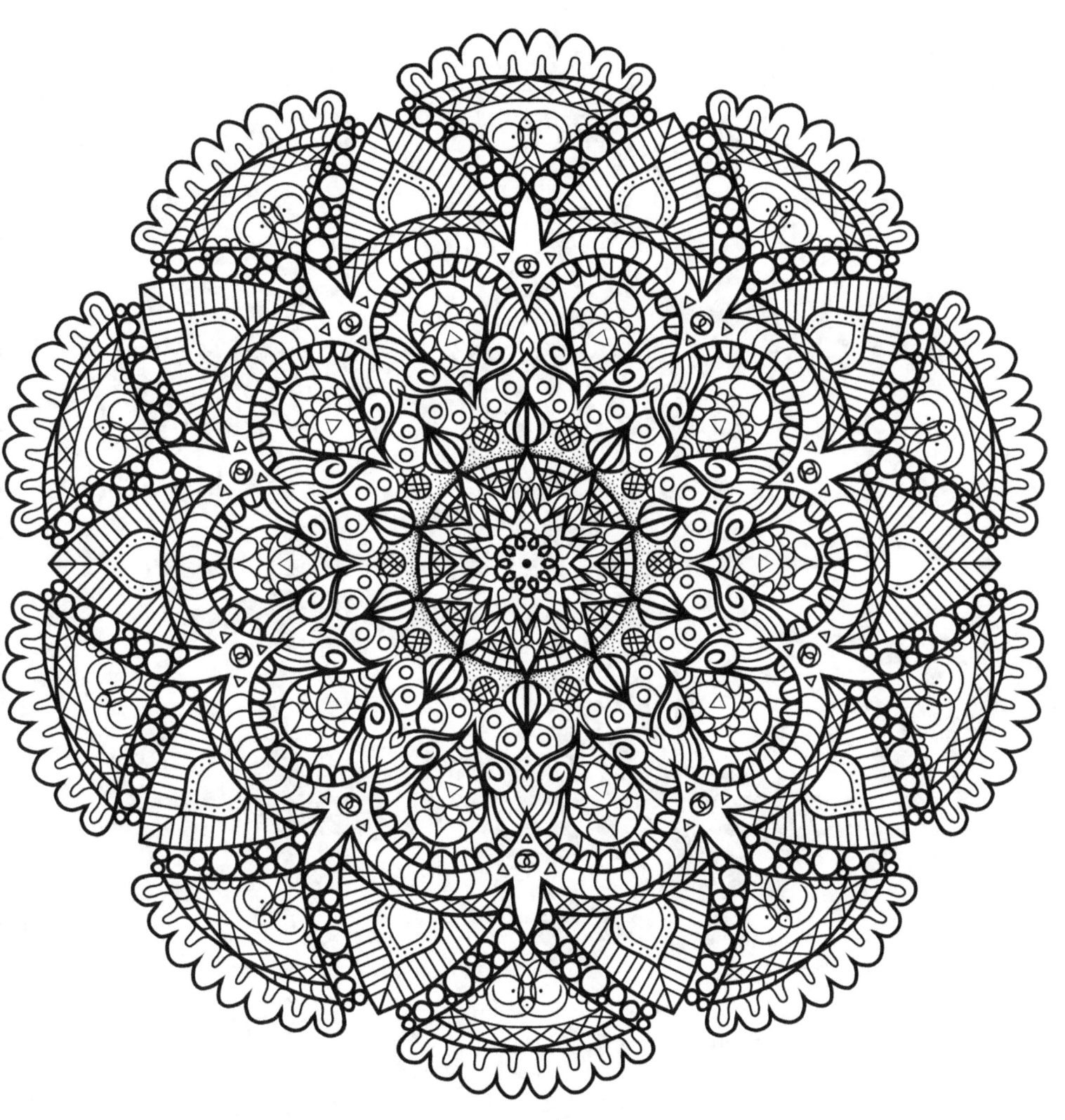

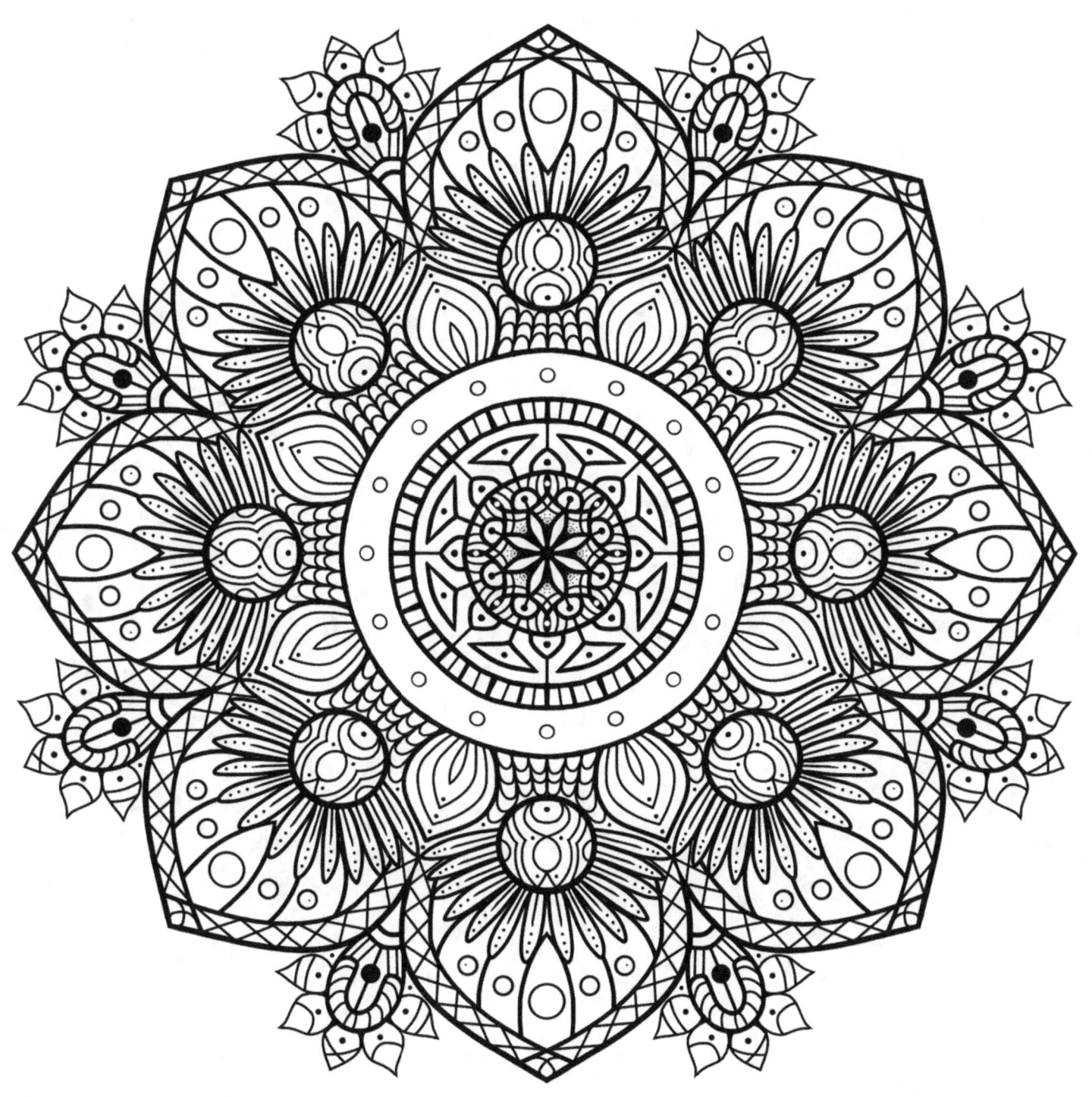

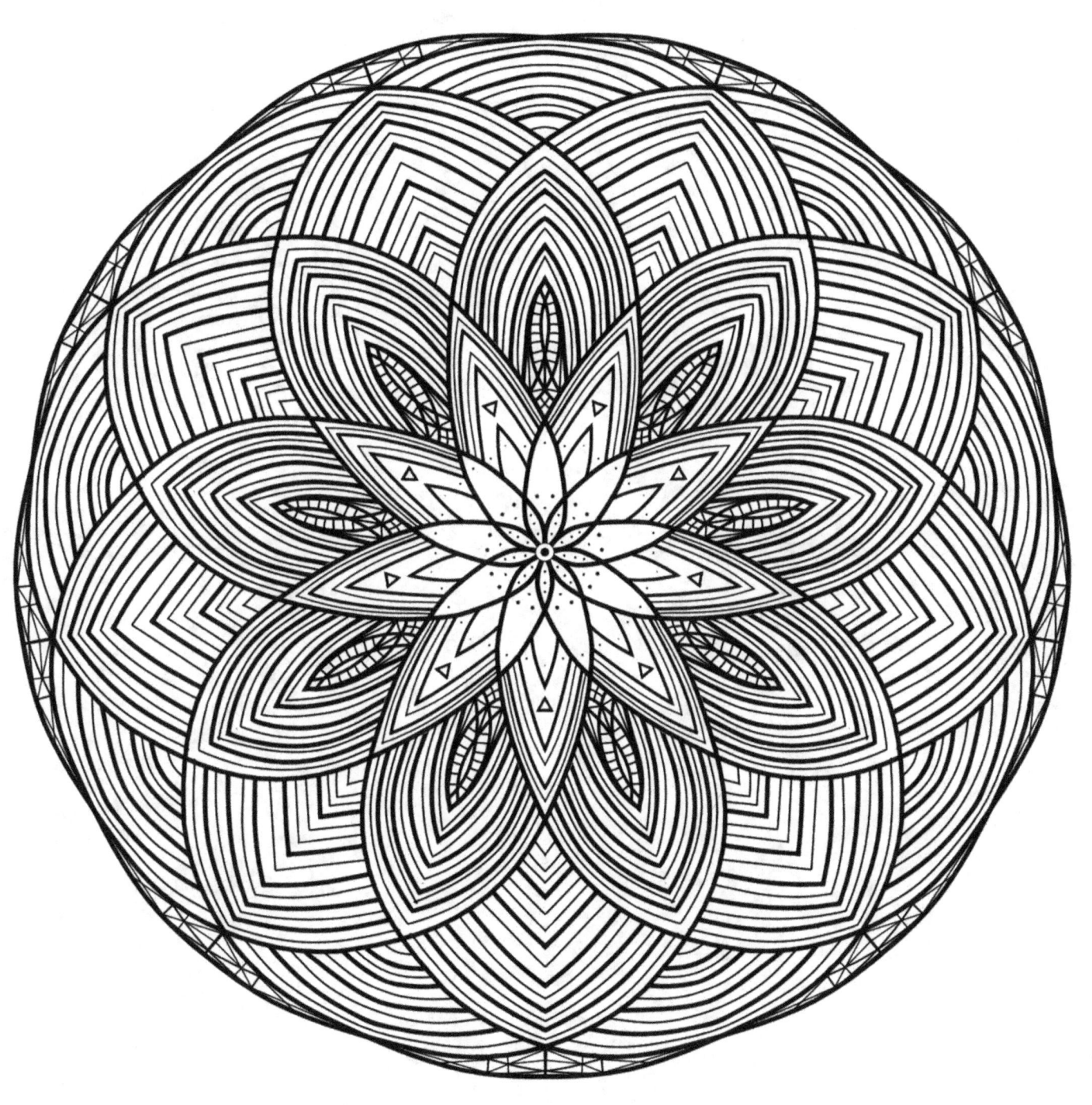

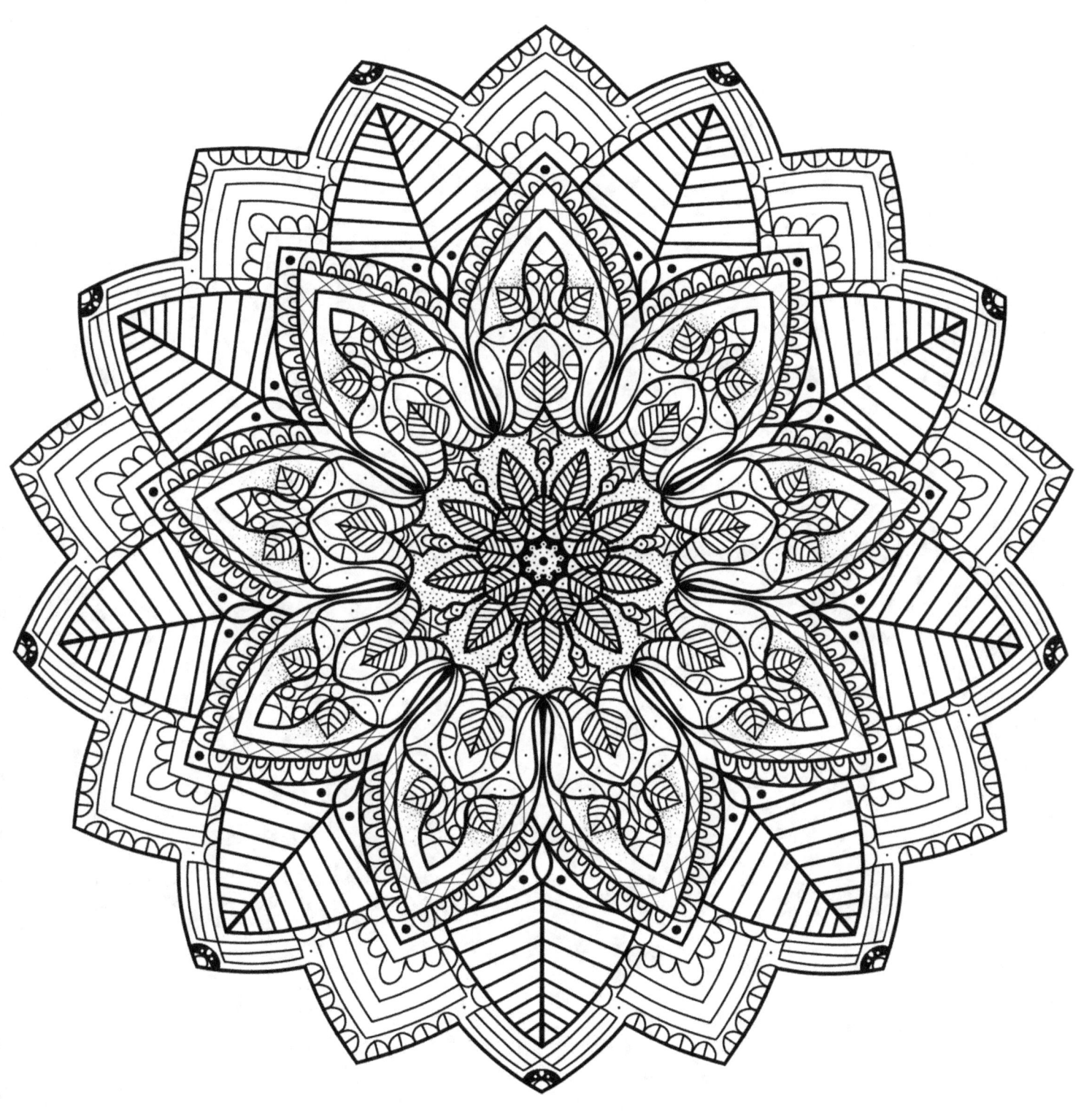

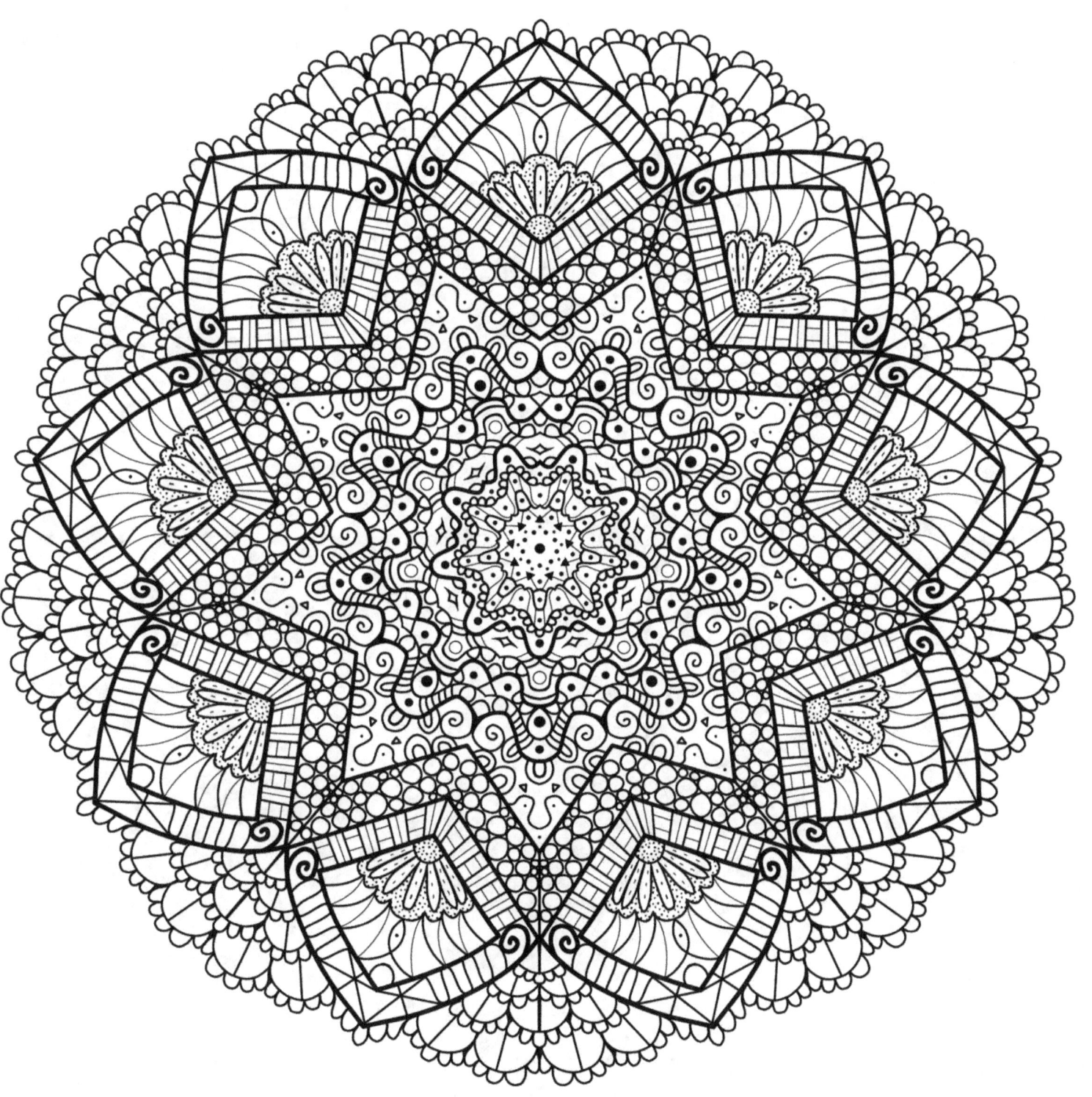

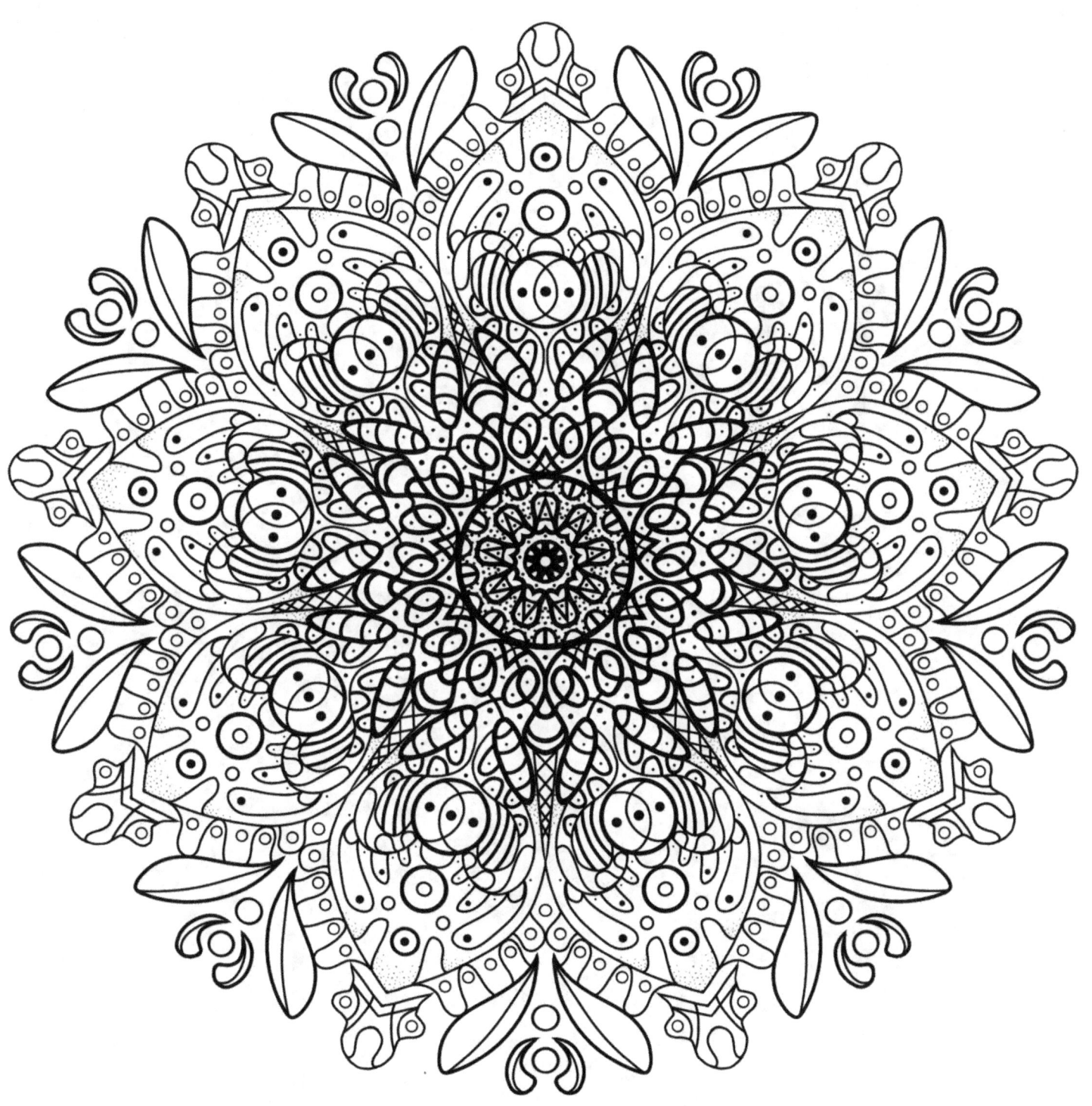

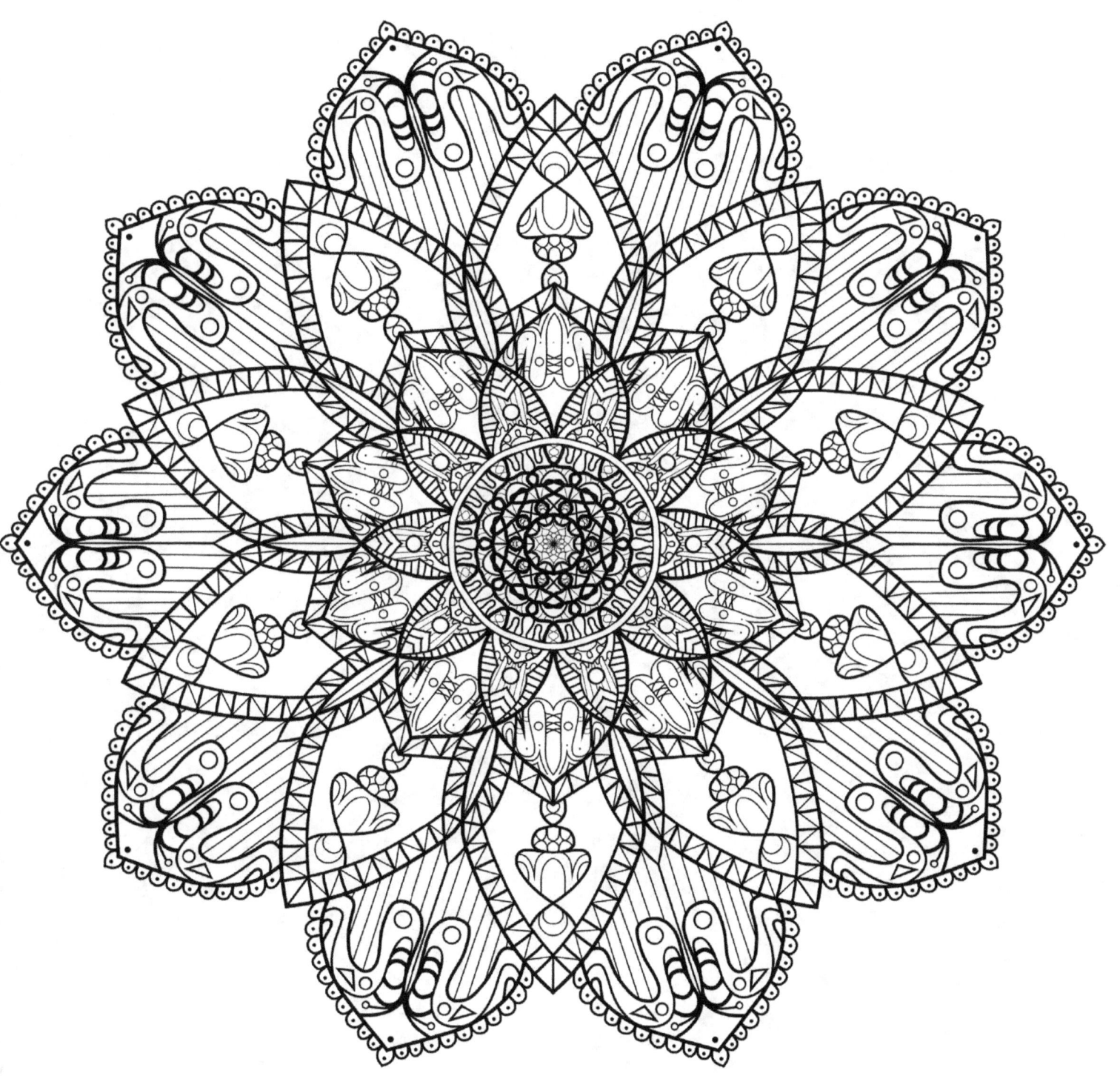

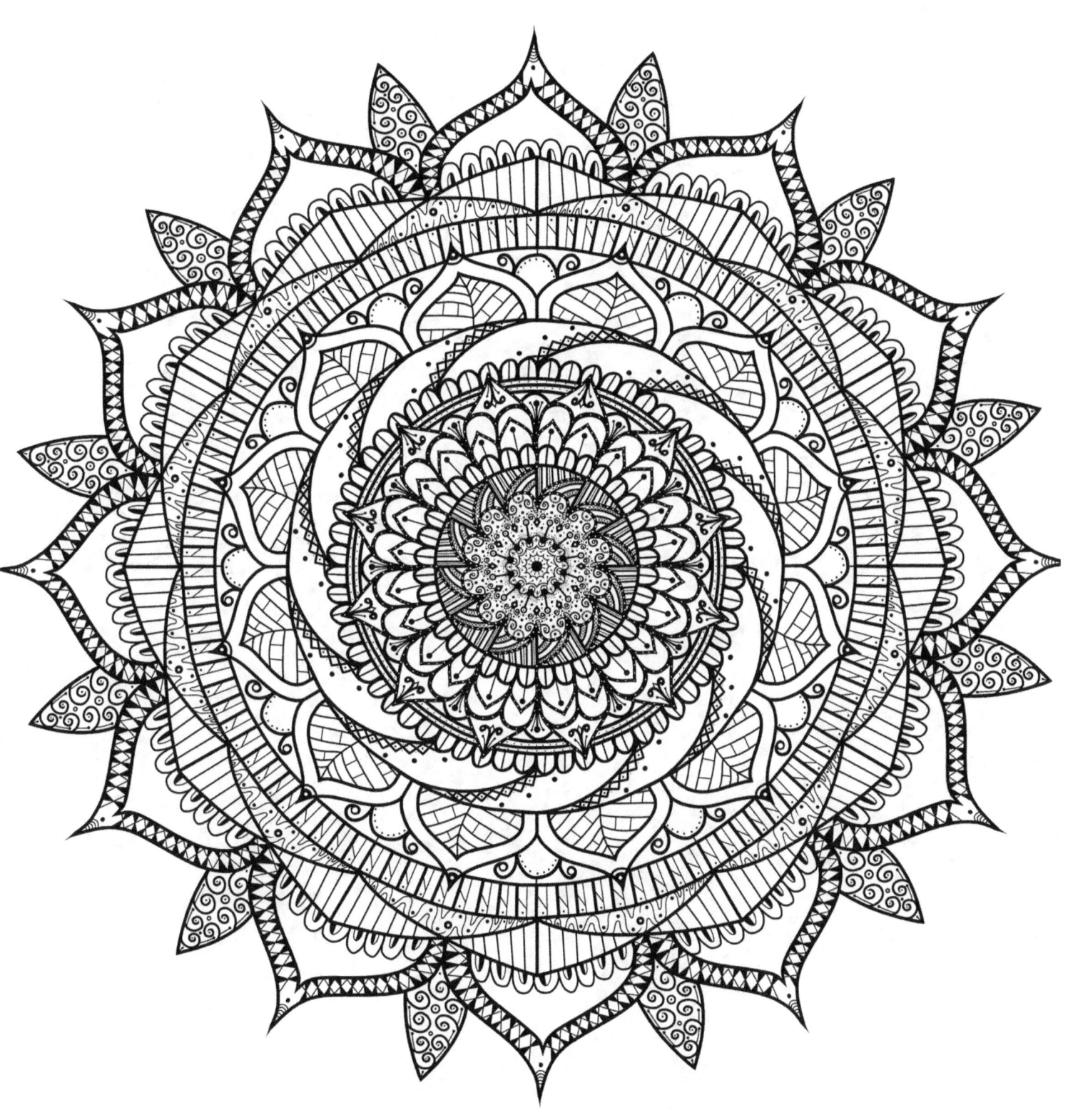

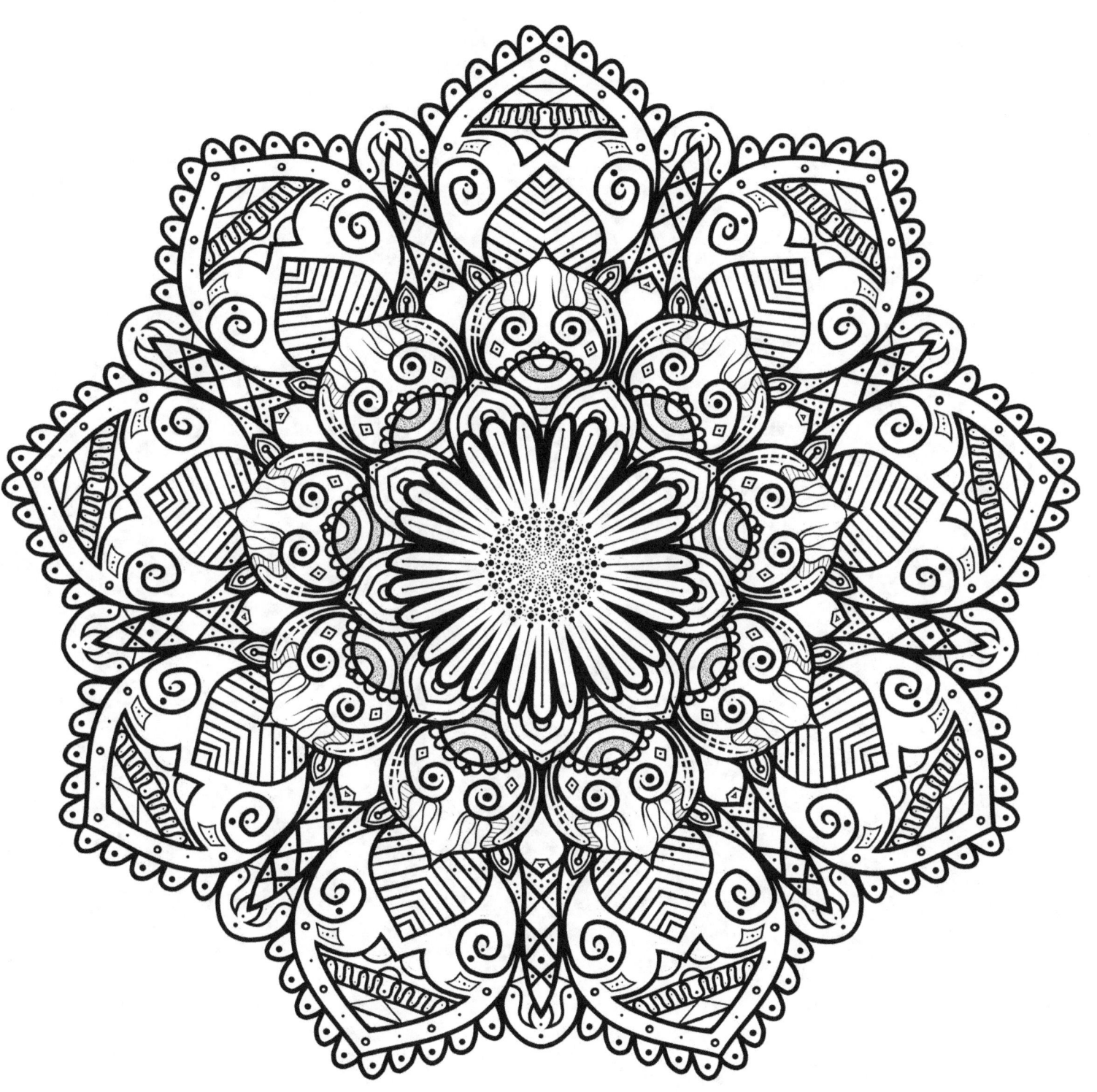

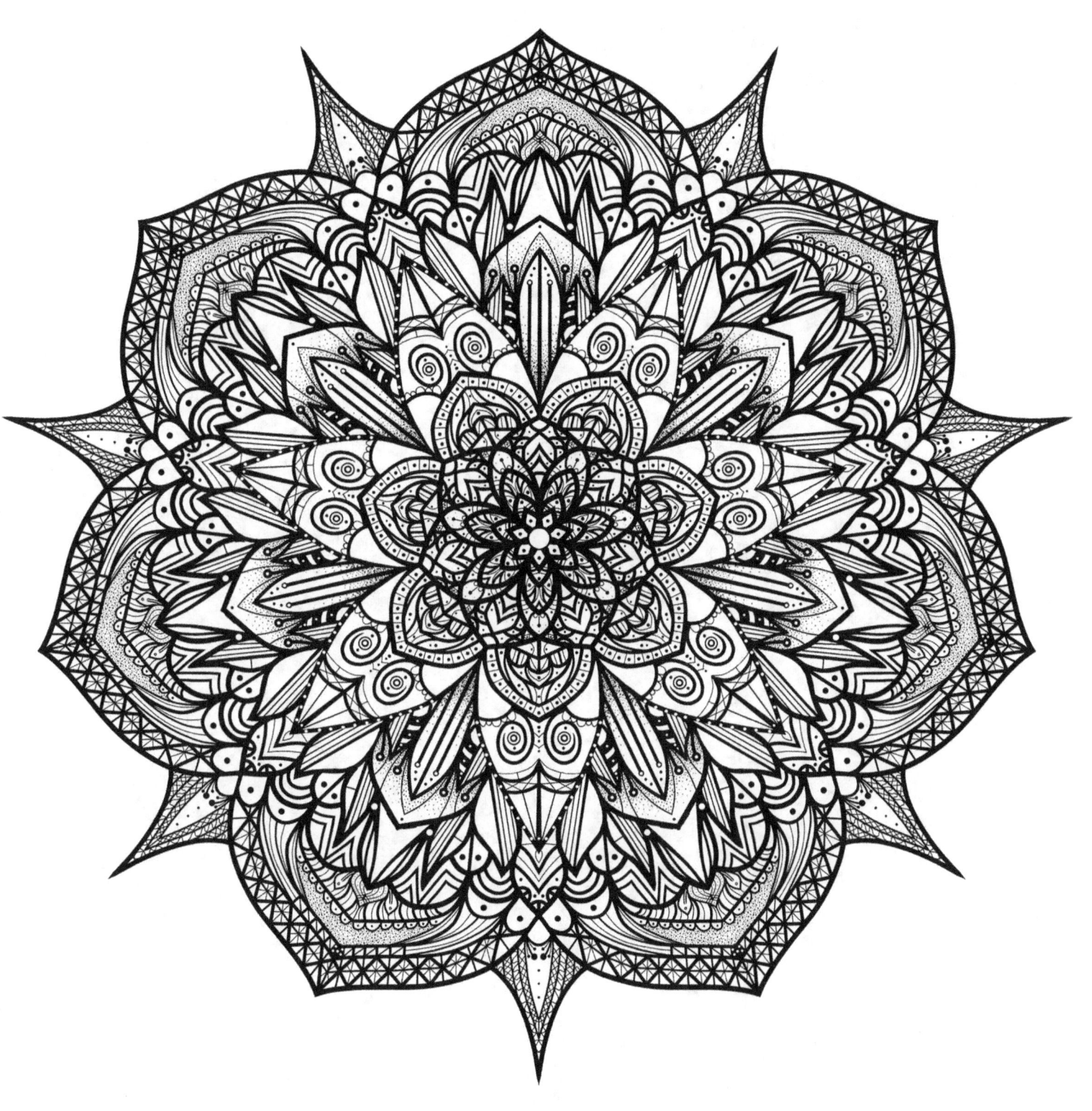

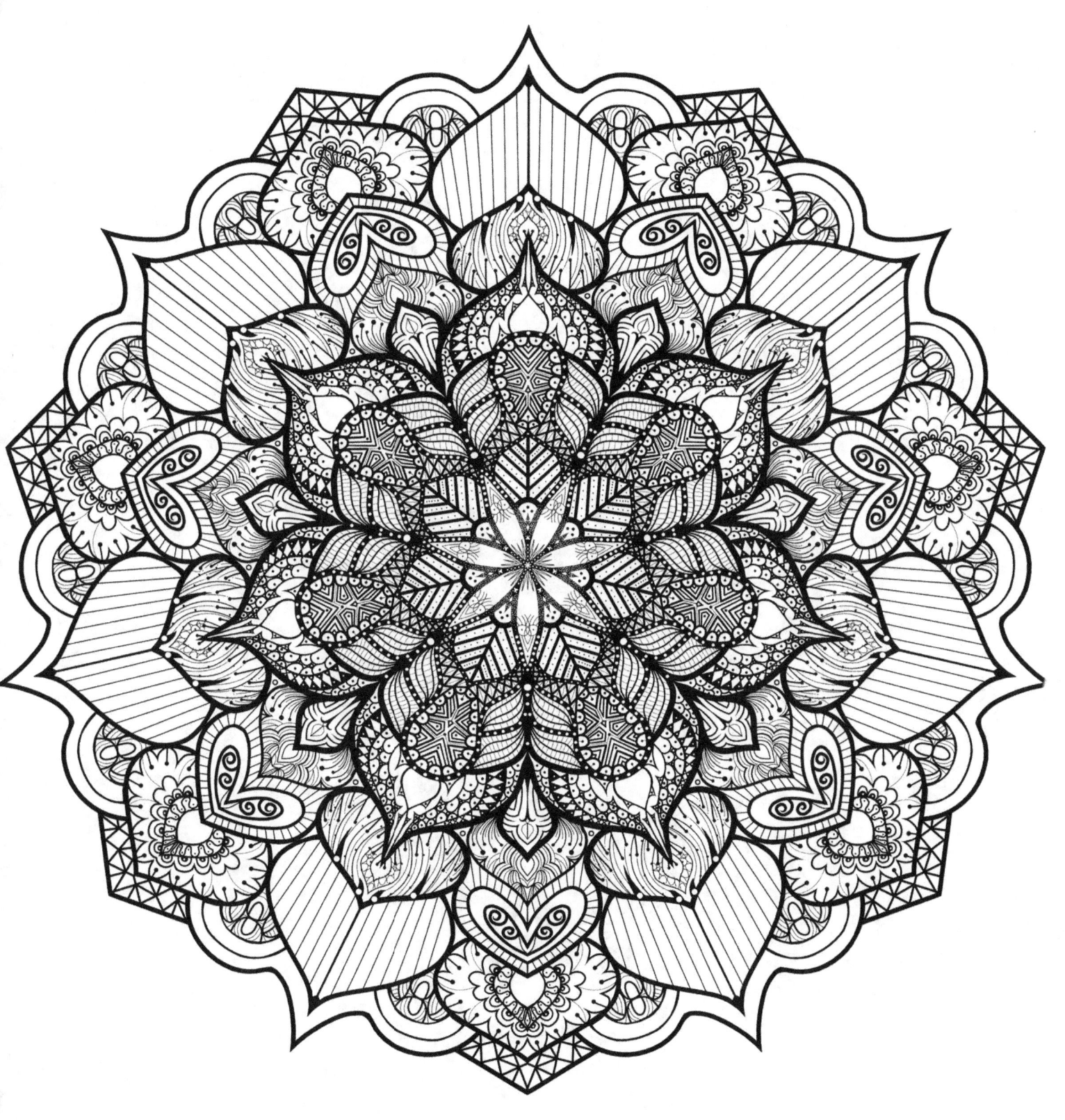